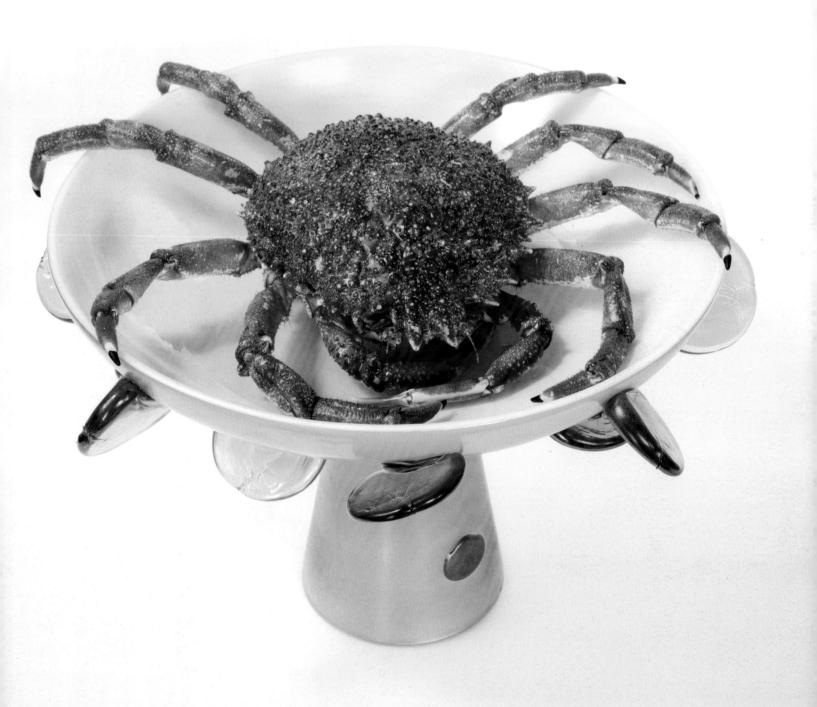

To Peter R.
Thank you for helping me make sense
of and systematize the puzzle.
I will be for ever grateful

To Marcella Hazan
My mentor and inspirer

Enrica Rocca

VENICE ON A PLATE

BUT WHAT A PLATE!

photographs by Jean-Pierre Gabriel

Marsilio

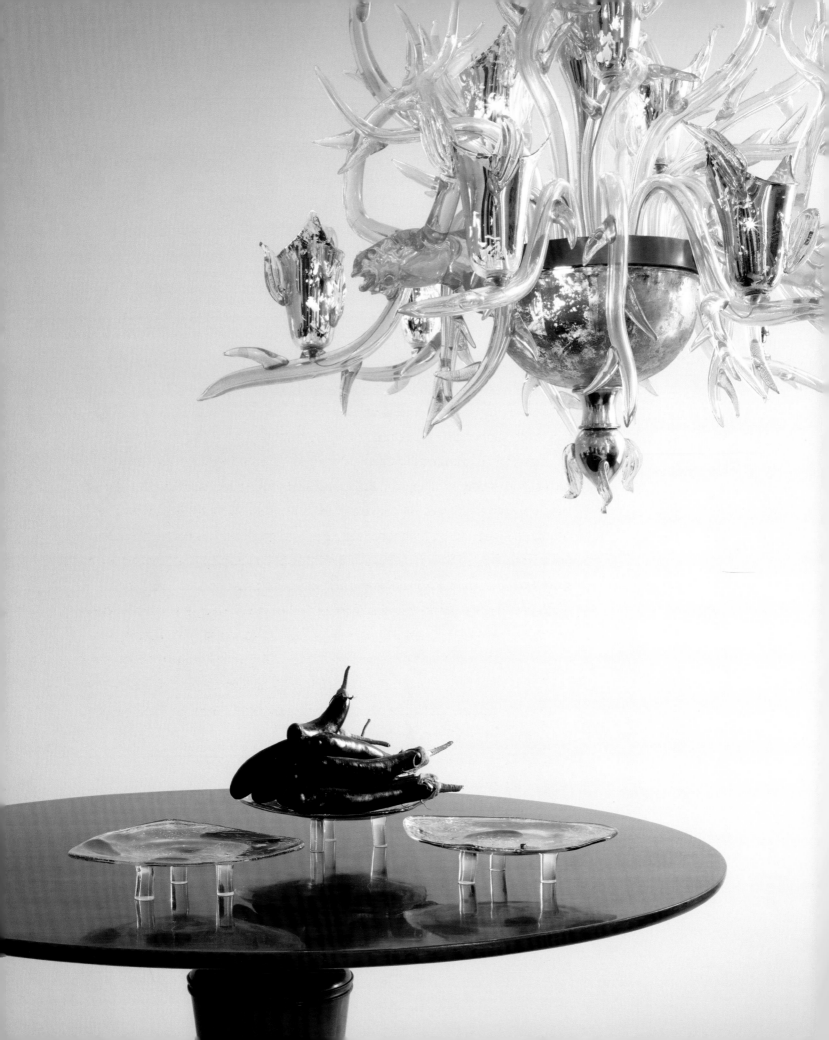

THE MARRIAGE OF MURANO AND VENICE
A VERY BEAUTIFUL MARRIAGE...

Pierre Rosenberg
Member
of the Académie française,
President and director
of the Musée du Louvre

Murano was, is still, and will for a long time continue to be the glass industry, artisanal glass production, and the art of glass in all its extraordinary variety, stupefying vitality, and inexhaustible creativity. Venice is art made cuisine, and cuisine made art—a cuisine that has been exported to the four corners of the world, with its delicacies and surprises, its ability to renew itself constantly, following changing seasons and fashions.

This book is the marriage of cuisine and glass, but it is also the happy marriage of creative photography and resourceful gastronomic literature. You will leaf through the book for pleasure (your own and that of others), for the images and malicious juxtaposing of a breast-shaped bowl held up by an audacious hand and an enticing *peperonata*; you will leaf through it all the more attentively for the outlandish, and sometimes provocative, contrast between a bowl in the shape of a bird's claw and *osei*. This book is also a treasure trove for those who are seeking the perfect recipe for great Venetian classics such as *spaghetti con le seppie al nero* or *sarde in saor*, or more obscure dishes such as *gnocchi di patate al pomodoro* or *maiale in tecia* (look up the book for the recipe; so as not to close up this parenthesis too brutally, I would advise you to try an amazing drink, *sgroppino*). Finally, the book is useful for those who would like to discover the works of bygone and current glass masters such as Judi Harvest, Richard Marquis, Massimo Micheluzzi, Ritsue Mishima, Aristide Nejean, Massimo Nordio, Maria Grazia Rosin, Marina and Susanna Sent, Lino Tagliapietra, and Toots Zinsky.

A book for the five senses.

Sight, which goes without saying,

taste, which wants no comment,

smell (oh, the incredible aroma of white truffles or a full-flavored risotto),

touch, be careful; glass is fragile…,

and I will let you guess hearing: for me, the restful and calming silence of Venice.

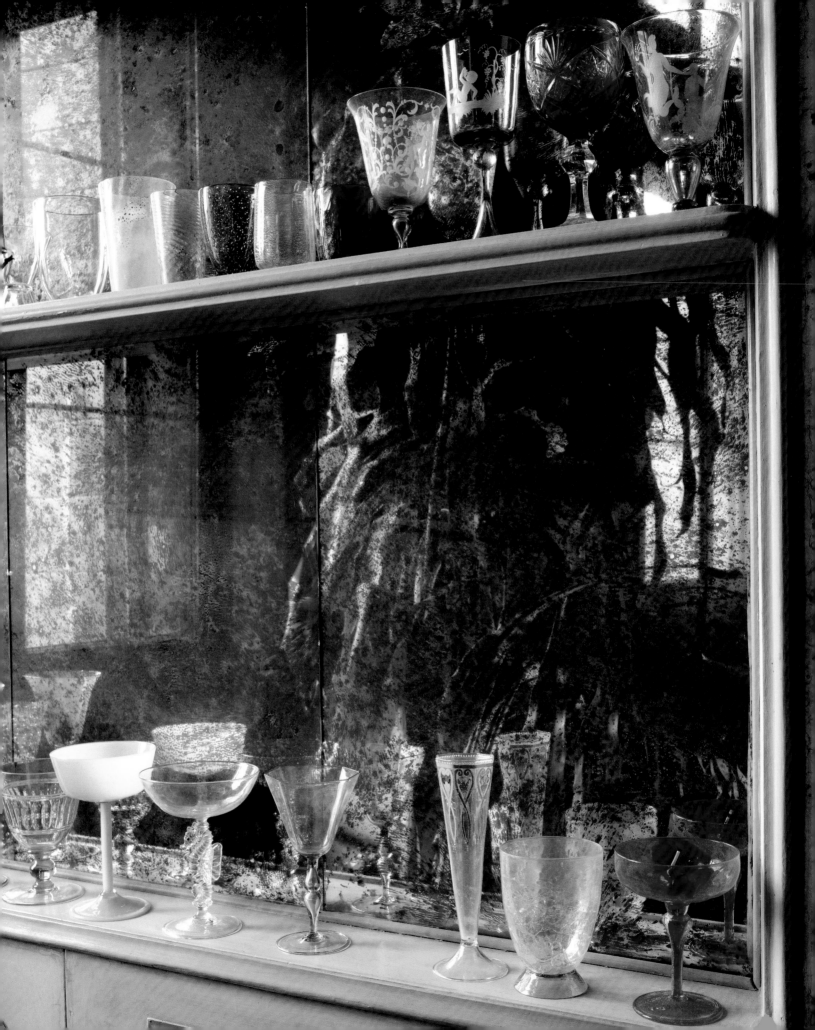

CONTENTS

TIPS AND HINTS

Enrica Rocca

A few years ago, when I decided I would one day write a cookery book, I set myself a few goals:

- The recipes would be simple and the ingredients of the highest quality
- All the dishes would be easy to make and would not be overly complex, regardless of what they might look like. I wanted my readers to feel confident that they would actually be able to make these dishes at home
- I would use a new concept, where beautiful art objects would be included as key players to add something special to dishes that, though they certainly taste wonderful, don't really always look stunning.

Food is our fuel, giving us energy and keeping us healthy and alive. So we should not be intimidated by the act of cooking—that would be like being scared of breathing right. Precisely because food is our fuel, the quality of what we eat is of paramount importance, and far too many people have forgotten just how significant that is. The preservatives, coloring, excess salt, hormones, and antibiotics found in mass produced animal proteins are all "ingredients" that will slowly affect our body and health.

There is a difference between food that simply fills you and food that satisfies you. One will simply suppress hunger, while the other will make you happy. The difference between the two is not huge—just a little extra time, love, and care.

Far too much food goes to waste in our modern first world society, and the biggest luxury of our times is that we can afford to be picky about food—never in human history has this been possible before now. Our ancestors were brilliantly ingenious at creating dishes where everything was used and nothing wasted—bones for stocks, giblets for pates and sauces, the head of fish and crustaceans for bisques, and so on. I'm convinced that we should go back and learn from them.

Good quality food can be expensive, and for most people this may require having to cut back on other things in their life (clothes, gadgets, and so on). But the benefits are such that it is may be worth considering. Ingredients change from country to country, so recipes don't always work or will require a little compromising. Only experience will

help here, and making mistakes is the best way to learn. If recipes exist, it is because one day someone dared to put those ingredients together. So dare and relax!

A good dish is a balanced dish. The main ingredient should be the relevant one and ought to dominate the dish. The other ingredients are there to enhance the flavor of this main ingredient and not kill or overwhelm it.

You should never be afraid of experimenting in the kitchen—atomic bombs are not created in pots and pans! If you add a bit more or put in a bit less of this or that ingredient, nothing untoward or dangerous will happen. Scales, measuring cups, timers, and so on only spoil the pleasure of cooking. These tools are nowhere to be found in my kitchen (which is why I don't do many desserts, where far too much precision and chemistry is involved while I like being completely spontaneous).

When you go shopping for food, don't think about recipes—think about ingredients! Buy the best, and then think about what you can do with it.

An empty pot or pan is like an empty canvas for an artist: ingredients are nothing other than colors, flavors, and textures that can be combined in many different ways. So just use your imagination and, again, with time and experience it will all become easy.

Remember to taste everything! Every time you encounter a new ingredient in your own country or while travelling, just taste it and try to imagine how you could use it. That is the only way to really discover the world of food.

Be curious about where the food you eat comes from. Go and pick mushrooms in the mountains, go fishing, pick your own vegetables on a farm, and go and see where your meat is bred. Being in touch with nature will help you better appreciate your food and the hard work and effort that farmers put into supplying you with great produce. The food industry is a multi-multi-billion-dollar industry, and therefore one you can no longer trust. So always read the labels! When there are more E's than proper ingredients, leave it on the shelves!

Happy cooking!

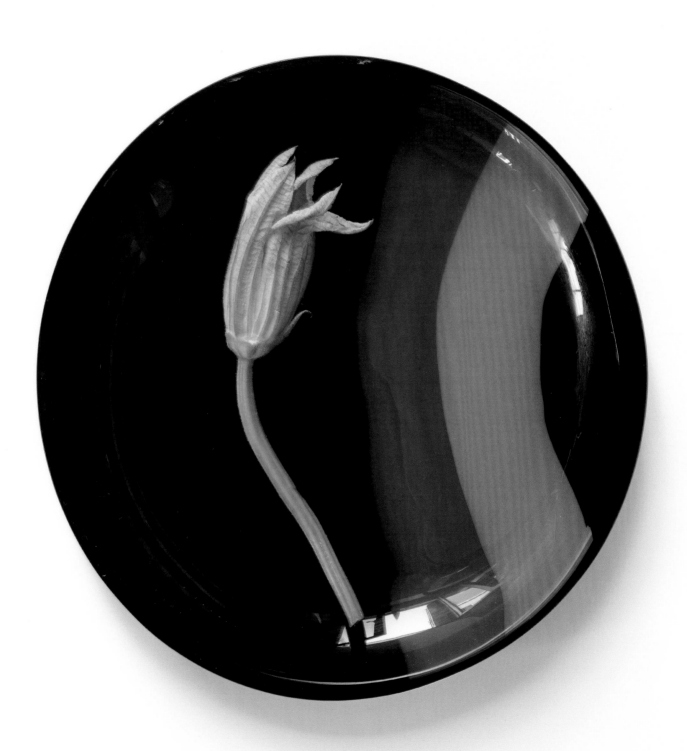

DRINKS AND NIBBLES

SPRITZ

The Spritz (from a German word meaning "splash") is a wine-based cocktail which originated in Venice when it was part of the Austrian Empire, and comes from the Austrian Spritzer, which is a combination of 50% white wine and 50% sparkling water. Venetians bring a twist to this drink by adding ingredients that satisfy their more demanding palate and thirst for serious alchool. Aperol would be the sensible choice if you're having this before lunch and still have work to deal with. With its 11% alcohol content, it shouldn't prevent you from productively resuming your office work. The much stronger Campari is a better choice for weekends or an evening drink.

PUT
the ice cubes in a tumbler, to fill at least half of the glass.

POUR
the wine or the Prosecco and

ADD
the Aperol, Bitter, Select, or Cynar.

LASTLY, ADD
a splash of soda water or seltzer.

STIR
gently, then decorate your glass with the slice of orange and the olive on a stick.

INGREDIENTS

2 parts
white wine or Prosecco

1 part
Aperol, Bitter Campari, Select, or Cynar

1 splash
soda water or seltzer

half a slice of orange

1
olive threaded
onto a cocktail stick

ice cubes

preparation time
5 minutes

serves 1

Glasses from
the *Asimmetrico* series
Carlo Moretti, 1986

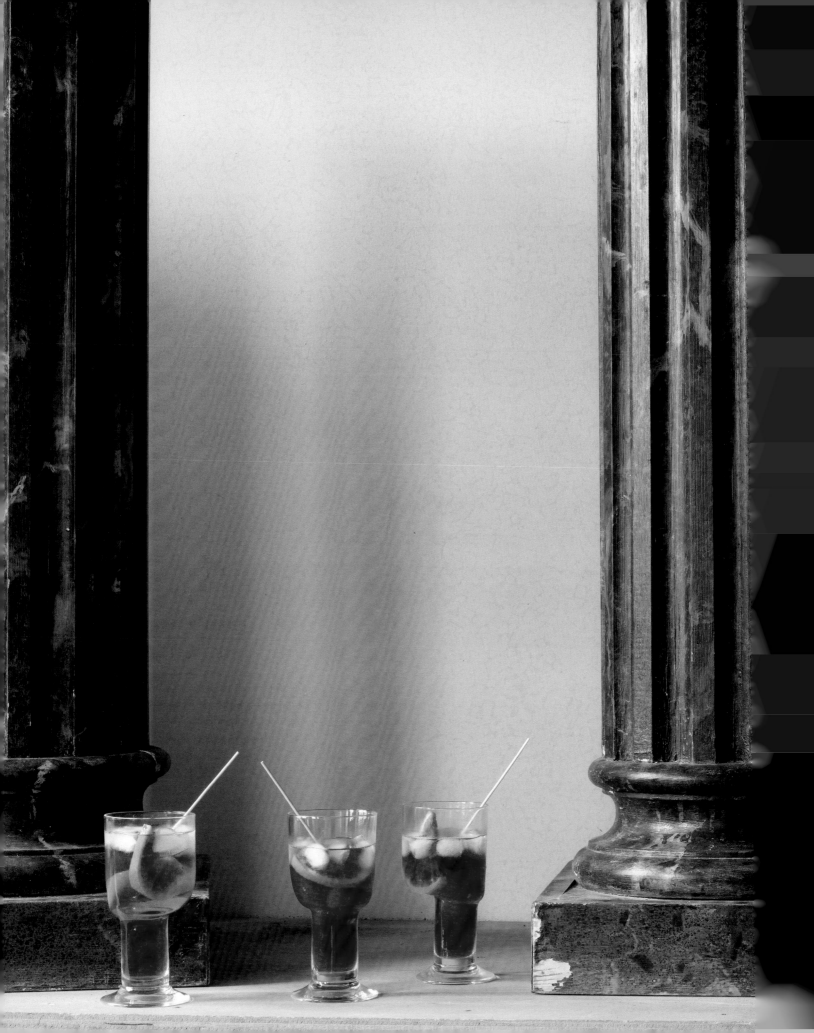

COCKTAIL ALLA FRUTTA
(FRUIT COCKTAILS)

General notes on fruit based cocktails
The correct proportion for all these drinks should be one third fruit juice and two thirds Prosecco. A perfect cocktail should always have an element of sweetness, an element of acidity, and an alcoholic element. Lemon will provide the acidity and, as it's a natural antioxidant, it will also help preserve the natural color of the fruit juice. Sugar is the sweet element, and the amount of sugar needed will vary depending on how ripe the fruit is. You should always add the sugar slowly and taste as you go. Each fruit will have to be treated differently for the perfect juice. If you've made more fruit juice than you need for the recipe, you can keep it in the fridge for a day or so or freeze it for the next occasion.

BELLINI (SUMMER)

Most people who come to Venice want to try a Bellini, a signature drink originally created by Giuseppe Cipriani at Harry's Bar in 1948. Because of its pink color, it reminded him of the dress of a character in a painting by the famous Venetian artist Giovanni Bellini.
What most people don't know, however, is that the Bellini cocktail is really only "in season" in the summer months, when you'll find the juiciest, sweetest white peaches. Every season, after all, has its drink with its own fruit, and people used to look forward to the change of flavors.

PEEL
and slice the peaches.

MARINATE
them in lemon juice and sugar for a few hours.

PLACE
the peaches and juices released in a food processor and pulse until you obtain a consistently smooth juice.

FILTER
the juice through a chinois, or fine-mesh strainer.

FILL
a flute with one third fruit juice and very slowly top with Prosecco. The Prosecco will foam as it reacts to the juice, so if you want to make more than one use a carafe and then fill the flutes.

INGREDIENTS

1kg
white peaches

juice of 1 lemon

100 to 200gr
of sugar, depending
on the ripeness of the fruit

Prosecco to top

preparation time
10 minutes

serves 6

following pages
Glasses from the
Calici collezione series
Carlo Moretti, 2007, 1994,
1993, 2009

TIZIANO (FALL)

Autumn is the season of *uva fragola* (strawberry grapes). Originally from the US, these grapes were imported to Europe when it was discovered that the Philostera, which had decimated vineyards, did not affect American vines. This very particular red grape has a subtle flavor that is reminiscent of strawberry and, once macerated, creates a lovely purple color that you can see in some of Titian's paintings (Titian is Tiziano in Italian, hence the name of the cocktail).

PLACE
the grapes in a food processor with the lemon juice and sugar (add the sugar gradually and taste as you go along).

LET
the juice marinate for a few hours to allow the skins to give color to the juice (the juice of any red grape is actually white and only the contact of the white pulp with the broken skins will give color).

FILTER
the juice through a chinois, or fine-mesh strainer.

FILL
a flute with one third fruit juice and very slowly top with Prosecco. The Prosecco will foam as a reaction to the juice, so if you want to make more than one, use a carafe and then fill the flutes.

INGREDIENTS

**1kg
strawberry grapes**

juice of half a lemon

**100 to 200gr
sugar depending
on the ripeness of the fruit**

Prosecco to top

preparation time
10 minutes

serves 6

MIMOSA (WINTER)

When winter arrives, oranges reach their perfect maturation and are used to create this amazing drink. Oranges have a good level of acidity, so you won't need to add any lemon juice. The original recipe only calls for navel oranges, but I also love it with the superb blood oranges that come a little later in winter.

PLACE
the orange juice in a food processor with the sugar (add the sugar gradually and taste as you go along).

FILTER
the juice through a chinois or fine-mesh strainer to eliminate any pips.

FILL
a flute with one third fruit juice and very slowly top with Prosecco. The Prosecco will foam as it reacts to the juice, so if you want to make more than one use a carafe and then fill the flutes.

INGREDIENTS

**1lt
freshly squeezed
orange juice**

**100 to 200gr of sugar,
depending on the ripeness
of the fruit**

Prosecco to top

preparation time
5 minutes

serves 6

ROSSINI (SPRING)

Created in honor of the famous Italian composer Gioachino Rossini, this cocktail makes its appearance in spring when strawberries arrive.
The quality and sweetness of the strawberries will make all the difference.

PLACE
the strawberries in a food processor with the lemon juice and sugar (add the sugar gradually and taste as you go along).

FILTER
the juice through a chinois, or fine-mesh strainer.

FILL
a flute with one third fruit juice and very slowly top with Prosecco. The Prosecco will foam as it reacts to the juice, so if you want to make more than one use a carafe and then fill the flutes.

INGREDIENTS

**1kg
strawberries**

juice of 1 lemon

**100 to 200gr sugar, depending
on the ripeness of the fruit**

Prosecco to top

preparation time
10 minutes

serves 6

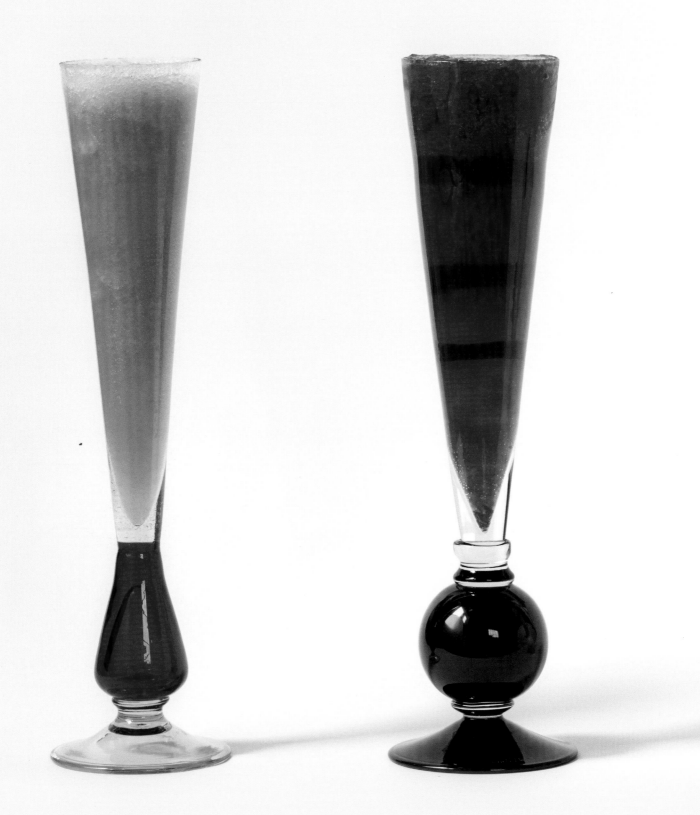

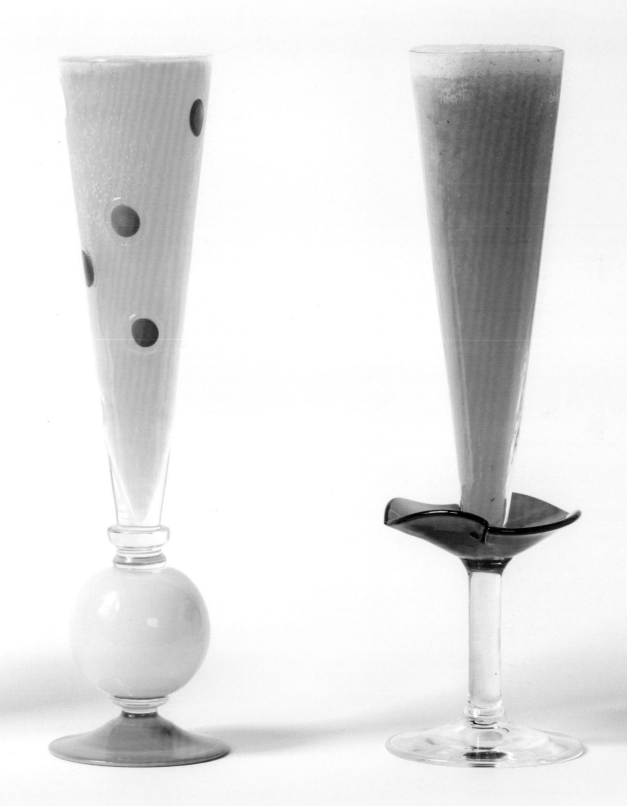

TRAMEZZINI

It was the illustrious Italian poet Gabriele d'Annunzio who created the word *tramezzino* to replace the then commonly used English word "sandwich," and in the 1960s the *tramezzino* became famous as the perfect accompaniment to the Spritz. With its distinctive triangular shape and generous filling, the *tramezzino*, when properly made, is one of the best sandwiches in the world. The soft, crustless bread used to make this delicacy is specially produced as *tramezzino* bread, and generally respects established tradition. It can be replaced by crustless toasting bread, even though the result is not exactly the same—the particularly humid conditions of Venice keep the bread soft and moist. Top quality main ingredients and good, homemade mayonnaise (see below for the proper recipe) are the secrets to success. There is an infinite array of different *tramezzini*, and some will be limited to certain periods of the year as they require the use of vegetables that should be freshly prepared and not canned. It would be impossible to give the recipes for all of them, so I will stick to the most popular ones even if, in reality, you can create *tramezzini* with any leftover whatsoever (for example, thinly sliced roast-beef and arugola or rocket salad leaves with a touch of fresh horseradish, porchetta, and lettuce with mustard, hard-boiled eggs, and good quality anchovies…).

MAYONNAISE

PLACE
2 egg yolks and ½ teaspoon of French mustard in a food processor.
The French mustard is a harmless way of guaranteeing success, as it will prevent the mayonnaise from separating without really altering the taste.

BLEND
the eggs and mustard for 1 minute (especially recommended if the eggs are taken directly from the fridge, as this will warm them up).

START
adding the oil by drizzling it very slowly into the food processor.

WHEN
all the oil has been incorporated, add the lemon juice, salt, and pepper.

INGREDIENTS

2
egg yolks

½ tsp
French mustard

200ml
sunflower oil

50ml
extra virgin olive oil

juice of 1 to 2 lemons,
depending on the size
and quantity of juice

salt and black pepper, to taste

preparation time
15 minutes

TONNO E UOVA (TUNA AND EGGS)

PLACE
an egg in a small saucepan and cover with cold water.

PLACE
on the stove and bring to the boil. Cook for 7 minutes once water starts to boil.

COOL
the egg under cold water, then peel and slice thinly.

PLACE
the tuna in a bowl and crush it with a fork. Add the mayonnaise and mix well until you obtain a very smooth but firm consistency (you can also do this quickly and easily in a food processor). Adjust the amount of mayonnaise if necessary.

SEASON
with salt and pepper if necessary.

PLACE
sliced bread on a board and place a generous dollop of the tuna and mayonnaise mixture in the center of the slice.

TOP
with the egg slices.

COVER
with the second slice of bread after spreading it with a little mayonnaise, and press the sides to seal the filling in the bread.

CUT
into 2 triangles. If you do not intend to eat the tramezzini immediately, cover them with a slightly damp cloth and wrap tightly in cling film to keep them moist for a couple of hours.

VARIATIONS
tonno e olive: replace the hard-boiled egg with a few pitted green or black olives
tonno e cipolline: replace the hard-boiled egg with pickled baby onions
tonno e asparagi: replace the hard-boiled egg with steamed asparagus
tonno e carciofini: replace the hard-boiled egg with good quality canned artichokes (sliced).

INGREDIENTS

2 slices of Venetian tramezzini bread, slices are horizontally cut and long (or 4 slices normal sandwich bread, crusts removed)

1 125gr
can of tuna in olive oil, drained

2 tbsp mayonnaise

1
hard-boiled egg, sliced

salt and black pepper, to taste

preparation time
15 minutes

serves 4

SALMONE AFFUMICATO (SMOKED SALMON)

PLACE
sliced bread on a board and spread with a little mayonnaise or cream cheese.

PLACE
generous portion of smoked salmon in the center of the bread.

TOP
with a few dill leaves.

COVER
with the second slice of bread after spreading it with a little mayonnaise, and press the sides to seal the filling in the bread.

CUT
into 2 triangles.

VARIATIONS
mixture of grated raw zucchini, cream cheese, and salmon.

INGREDIENTS

2 slices of Venetian tramezzini bread (or 4 slices normal sandwich bread, crusts removed)

200gr
good smoked salmon

2 tbsp mayonnaise
(or 2 tbsp cream cheese for a lighter result)

a few dill leaves

preparation time
10 minutes

serves 4

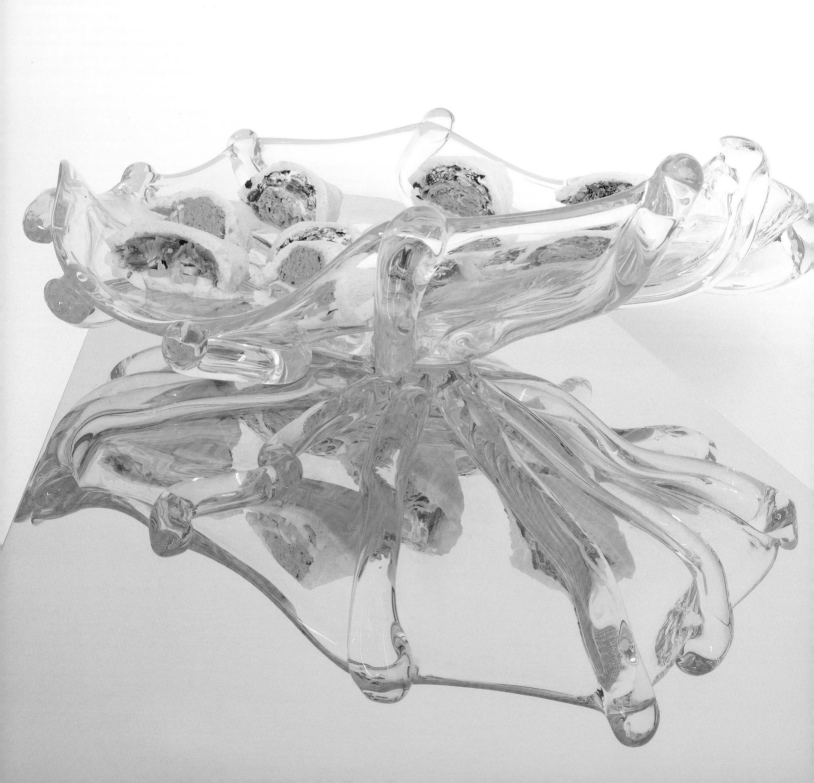

PROSCIUTTO E UOVA (HAM AND EGGS)

PLACE
an egg in a small saucepan and cover with cold water.

PLACE
on the stove and bring to the boil. Cook for 7 minutes once water starts to boil.

COOL
the egg under cold water, then peel and slice thinly.

PLACE
sliced bread on a board and spread with a little mayonnaise.

PLACE
slices of cooked ham in the center of the bread.

TOP
with a few slices of hard-boiled egg. Season with salt and black pepper if necessary.

COVER
with the second slice of bread after spreading it with a little mayonnaise, and press the sides to seal the filling in the bread.

CUT
into 2 triangles.

VARIATIONS
prosciutto e funghi: replace the hard-boiled egg with sautéed, finely sliced button mushrooms (you can use canned mushrooms, but the flavor is not the same)
prosciutto e asparagi: replace the hard-boiled eggs with steamed asparagus
prosciutto pomodoro e mozzarella: replace the hard-boiled egg with good quality, very thinly sliced buffalo mozzarella and very thinly sliced tomatoes.

INGREDIENTS

2 slices of Venetian tramezzini bread (or 4 slices normal sandwich bread, crusts removed)

200gr cooked ham

2 tbsp mayonnaise

1 hard-boiled egg, sliced

sea salt and black pepper, to taste

preparation time
15 minutes

serves 4

VEGETARIANO (VEGETARIAN)

VERY LIGHTLY COAT
the vegetables with olive oil and cook them in a grilling pan.

PLACE
sliced bread on a board and spread with a little mayonnaise or cream cheese.

PLACE
generous portion of grilled vegetables in the center of the bread.

TOP
with dill leaves, other herbs or a little pesto. Season with salt and black pepper if necessary.

COVER
with the second slice of bread after spreading it with a little mayonnaise, and press the sides to seal the filling in the bread.

CUT
into 2 triangles.

VARIATIONS
formaggio e verdure: add slices of mozzarella, or stronger cheese (shaved Gruyere, Parmesan, or similar)
uova e verdure: add slices of hard-boiled egg.

INGREDIENTS

2 slices of Venetian tramezzini bread (or 4 slices normal sandwich bread, crusts removed)

200gr mixed grilled vegetables (zucchini, eggplant, bell peppers, or anything that takes your fancy)

2 tbsp mayonnaise (or 2 tbsp of cream cheese for a lighter result)

a few dill leaves, or other herbs or pesto, to taste

sea salt and black pepper, to taste

preparation time
40 minutes

serves 4

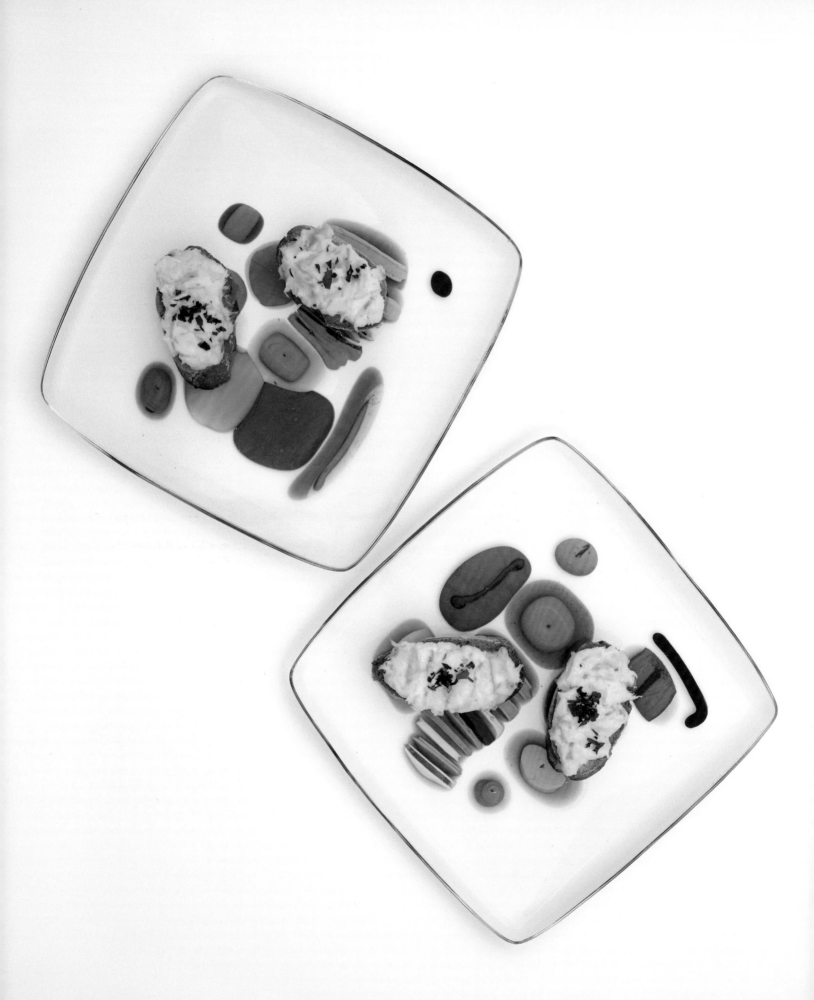

CROSTINI CON BACCALÀ MANTECATO
(CREAMY COD ON CROSTINI)

The nicest way to enjoy baccalà is in a *bacaro*, on a *crostino* (toasted slice of French baguette), or—my own favorite—on a warm slice of grilled white polenta (polenta used to be the Venetians' bread: it was cheap as corn was extremely common in the countryside, see page 138). The bubbles of a cold glass of Prosecco will help eliminate the fatty sensation on your palate.

SOAK
the stockfish in a lot of fresh water for at least 48 hours, changing the water often.

BRING TO THE BOIL
a pan with 1½lt salted water and milk, and cook the stockfish for 25 minutes, uncovered, on a low heat.

REMOVE
the skin and bones from the cooked stockfish, and using a fork, break the meat into small pieces.

INCORPORATE
the oil in a thin, constant stream (as if you were making mayonnaise) while beating the stockfish with a manual or an electric whisk until it is of a coarse but creamy consistency.

ADD
the freshly chopped garlic, parsley, and olive oil, if you're using it, and season with salt and pepper to taste.

SERVE
on toasted crostini or grilled polenta.

INGREDIENTS

500gr
dry stockfish

500ml
sunflower oil

500ml
milk

4 cloves
of garlic, finely chopped

4 tbsp
chopped parsley

1 tbsp
extra virgin olive oil (optional)

sea salt and black pepper,
to taste

preparation time
1h + soaking

serves 10

Plates
Marina and Susanna Sent, 2012

previous pages
Petalo plate
Ritsue Mishima, 2013

CICCHETTI
(MIXED NIBBLES)

Cicchetti are best described as finger food, or anything you can eat while standing with a glass of Prosecco or a Spritz in your hand. For this reason, all the *cicchetti* should be bite-sized and easy to eat with your hands or a toothpick. Every *bacaro* in Venice has its own specialties, and everyone can create their own with whatever they enjoy. Here's a list of some of the traditional *cichetti* you'll find in any good *bacaro* and a few recipes from some of my favorite *bacari*.

MORTADELLA E CIPOLLINA
a cube of mortadella and a baby pickled onion on a toothpick.

FORMAGGIO E PEPERONE
a cube of cheese and a small slice of pickled pepper on a toothpick.

SALAMINO PICCANTE
a thick slice of spicy salami which the Prosecco will tame with its slight sweetness.

UOVO E ACCIUGA
half a hard-boiled egg topped with an anchovy fillet, a blend that enhances the taste of the egg and balances the slight saltiness of the anchovy.

CALAMARETTO O SEPPIOLINA ALLA GRIGLIA
a grilled baby calamari or cuttlefish drizzled with a little olive oil and finely chopped parsley (see recipe page 46).

FOLPETTO
half a poached very small octopus drizzled with a little olive oil and finely chopped parsley (see recipe page 39).

CROSTINI CON CREMA DI ZUCCA E RICOTTA
a thick cream of pumpkin (roast the pumpkin, then simply mash and season to taste) topped with Ricotta cheese (better if you use buffalo milk Ricotta).

CROSTINI CON ROBIOLA E CREMA DI TARTUFO
Robiola is a smooth, creamy, delicately-flavored cheese which is perfect if mixed with a little truffle paste and decorated with a small piece of pickled porcini.

CROSTINI CON TONNO E PORRI
tuna and mayonnaise with a fine julienne of tender leeks.

CROSTINI CON GORGONZOLA E NOCI
a cream of Gorgonzola (just buy a piece of Gorgonzola or other blue cheese and mash it with a fork) with a little red or white port and decorated with half a walnut.

CROSTINI CON PROSCIUTTO, BRIE E POMODORO AL FORNO
good quality cooked ham, a thin slice of Brie, and an oven roasted tomato.

INGREDIENTS

mortadella, spicy hot salami, cooked ham

Pecorino cheese, Ricotta, Robiola, Gorgonzola or any blue cheese, Brie

pickled onions and peppers

roasted tomatoes

boiled eggs

anchovy fillets, baby calamari, baby cuttlefish, baby octopus, tuna

pumpkin, truffle paste, leeks

walnuts

Plates
Marina and Susanna Sent, 2010

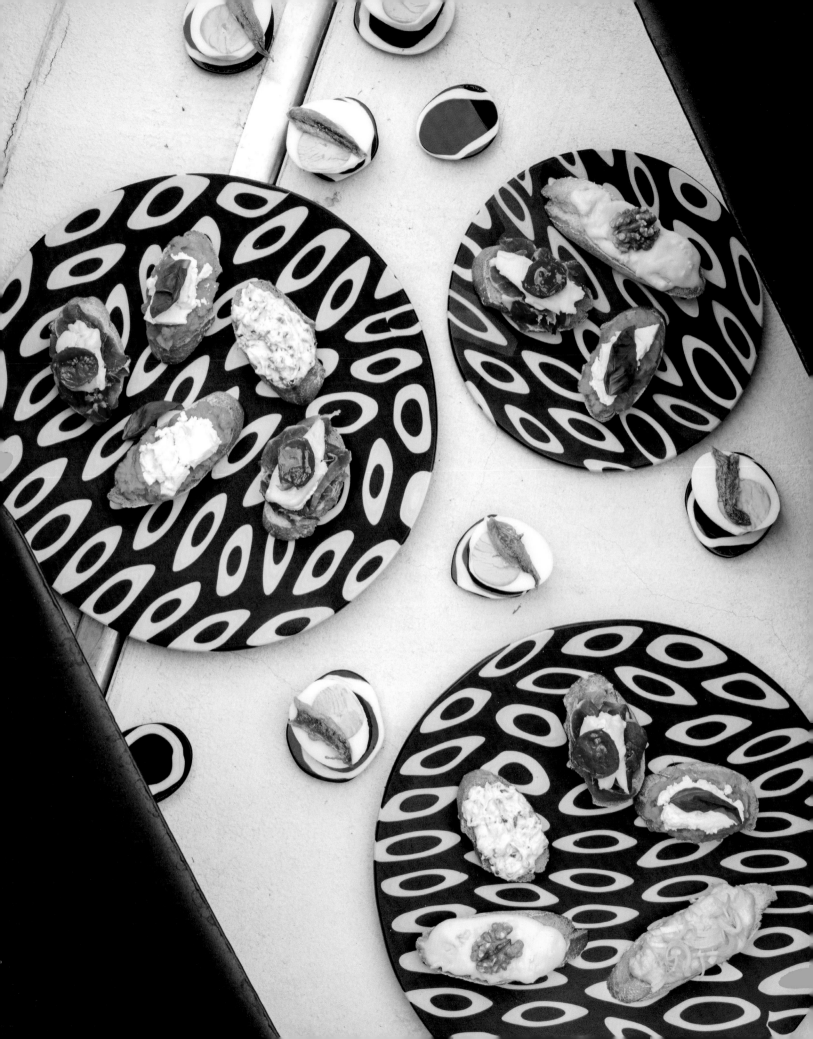

POLPETTE
(FRIED MEAT BALLS)

These meat balls are perfect as an accompaniment to aperitifs or a mid-morning Prosecco break, which is a very civilized Venetian habit. Traditionally, the meat is made moister through the addition of white, crustless bread soaked in milk then squeezed to remove any excess liquid. I find Ricotta to be a very good alternative to this method, but my favorite is asking the butcher to add some sweetbread or brain along with the meat before mincing it.

MIX

all the minced meat, nutmeg, and Parmesan cheese in a bowl and season with salt and pepper. Add parsley, and garlic.

STIR

in the eggs and mix thoroughly. Minced meat can be very dry, so you have 3 options to moisten the mixture:

ADD

150 of Ricotta cheese or

SOAK

200gr of rustic bread (crusts removed) in milk. Squeeze out any excess liquid, mince it and add it to the meat mixture or

ASK

your butcher for 200gr of sweetbread or brains. You can either ask your butcher to mince it in with the meat, or you can mince it yourself and add as much as you need. In this case, remove the skin-like membrane before mincing.

MIX

thoroughly with your hands. Let the mixture rest, if possible, for 4–5 hours or even overnight, so that the meat can absorb all of the flavors.

FORM

the meat mixture into little round balls (about 3cm) and roll them in breadcrumbs.

HEAT

enough sunflower oil to fill a 20cm diameter frying pan to a depth of about 4cm until it is very hot. Deep fry the meatballs for about 3 minutes on each side or until a golden crust forms.

PLACE

them on plate lined with a paper towel to absorb excess oil, and season with sea salt to taste.

INGREDIENTS

500gr
minced beef and pork, half and half

100gr
minced mortadella, or pure pork Italian sausage

4 tbsp
finely chopped parsley

2
cloves of garlic, finely chopped

2
medium eggs

150gr
Ricotta or rustic bread or sweetbread

80gr
grated Parmesan cheese

¼ tsp
nutmeg

sea salt and black pepper, to taste

120gr
bread crumbs

enough sunflower oil to fry (quantity will vary depending on the size of the pan)

preparation time
1h + rest time

serves 4

Feathers
Massimo Nordio, 2004

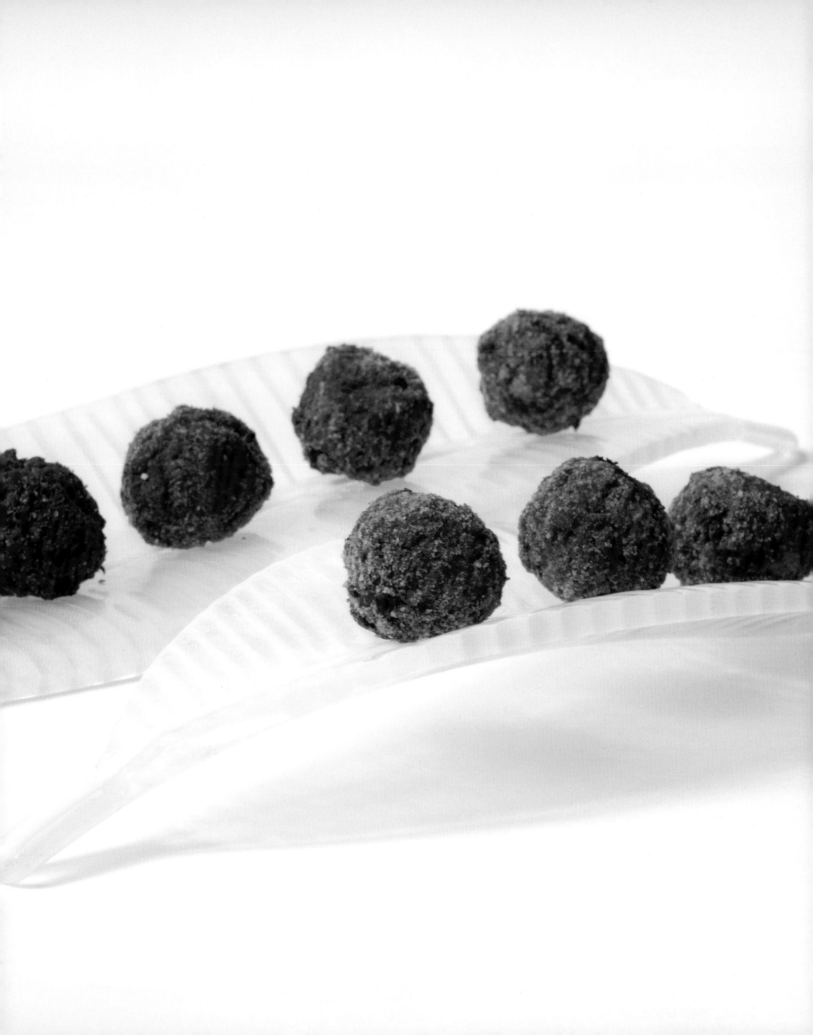

STARTERS

INSALATA DI MARE
(SEAFOOD SALAD)

Depending on where you live, this dish will vary as all kinds of seafood can be used in an infinite array of different combinations. The more varied it is the more interesting this dish will be, but if you have to compromise at all then you'd be better off limiting the variety and concentrating on the freshness of the ingredients. Frozen seafood, for example, loses a lot of its flavor and you will have to add a lot more ingredients to make it interesting and flavorsome.

CLEAN
the cuttlefish: wash them, remove the bone, the eyes, and the beak. Peel them and remove the ink pockets.

CLEAN
the calamari: remove the head, take off the cartilage bone, empty the tube completely and wash it thoroughly, cut the tentacles above the eyes, keep them and throw the rest away.

REMOVE
the beards and scrub the mussels clean using a table knife or a steel wool scourer to scrape off all impurities.

HEAT
1 tbsp of extra virgin olive oil in a pan until very hot. Add the mussels and wine.

COVER
with a lid and allow the mussels to open, but do not overcook (approximately 2–3 minutes will do).

REMOVE
the mussels from the pan and reduce the juices by half.

POUR
the juices into a small bowl and set aside.

BRING
a stock pot of salted water to the boil and when boiling add the scampi, red prawns, and king prawns.

COOK
for 5 minutes from the moment the water comes back to the boil.

DRAIN
all the seafood and set aside to cool.

INGREDIENTS

4
scampi

8
Sicilian red prawns

8
king prawns

8
baby calamari

4
baby cuttlefish

16
mussels

2 tbsp
extra virgin olive oil

20ml
dry white wine

100gr
young green leaf salad

1 tbsp
parsley, freshly chopped

for the seasoning

reduction
of the mussel juices

2 tbsp
extra virgin olive oil

coarse sea salt and black
pepper, to taste

preparation time
2 h

serves 4

HEAT
> a grilling pan, and lightly brush the calamari and cuttlefish with a little extra virgin olive oil.

ADD
> the cuttlefish and calamari and grill on both sides for about 2 minutes or until soft (time varies depending on the size of the calamari and cuttlefish).

ONCE
> the scampi and prawns have cooled, gently peel their tails off, making sure not to remove the heads.

PLACE
> the grean leaf salad and all the seafood in a serving dish. Use your imagination to create a nice presentation.

ADD
> extra virgin olive oil and pepper to taste to the reduced mussel juices, mix thoroughly and use this to dress the salad. Salt is usually not needed as the mussel juices are salty enough.

SPRINKLE
> with freshly chopped parsley.

following pages
Car 02/9
Richard Marquis, 2002

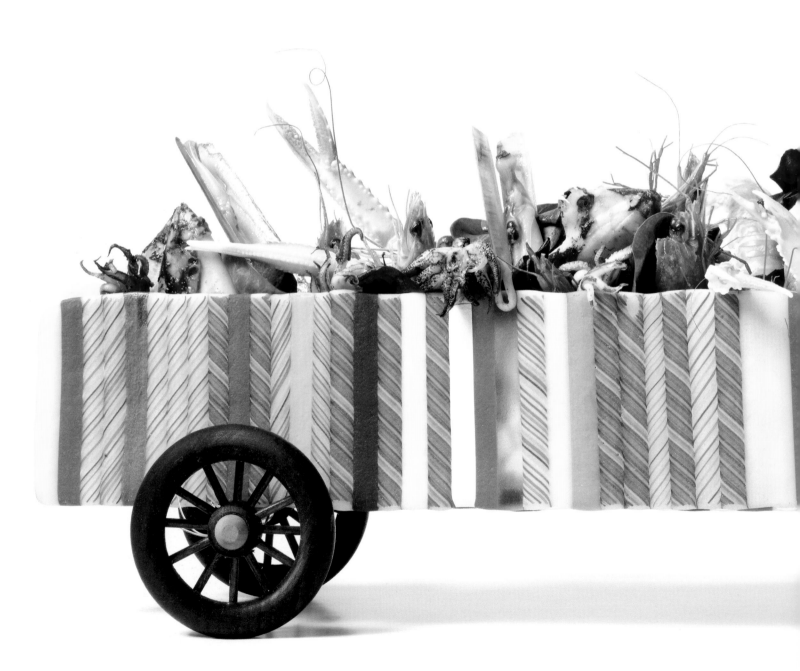

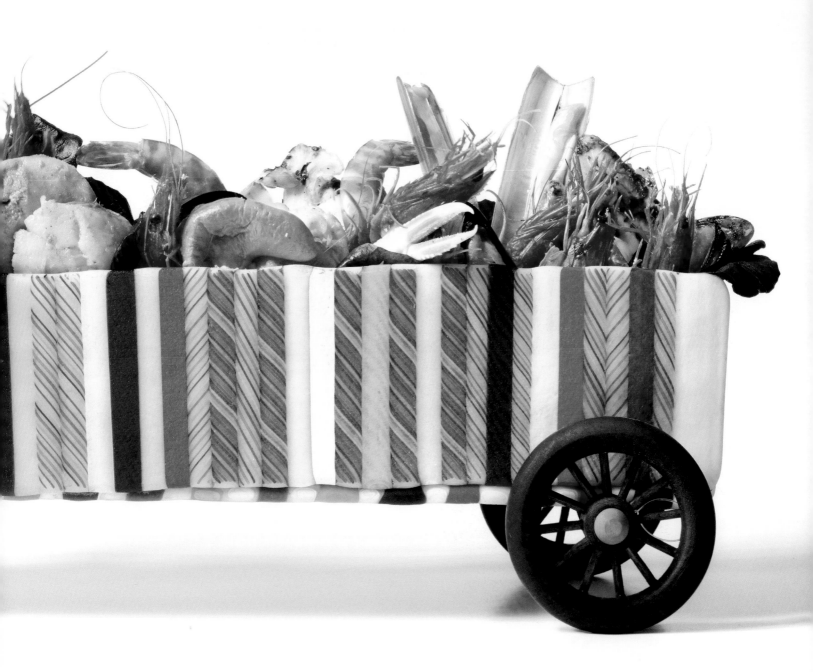

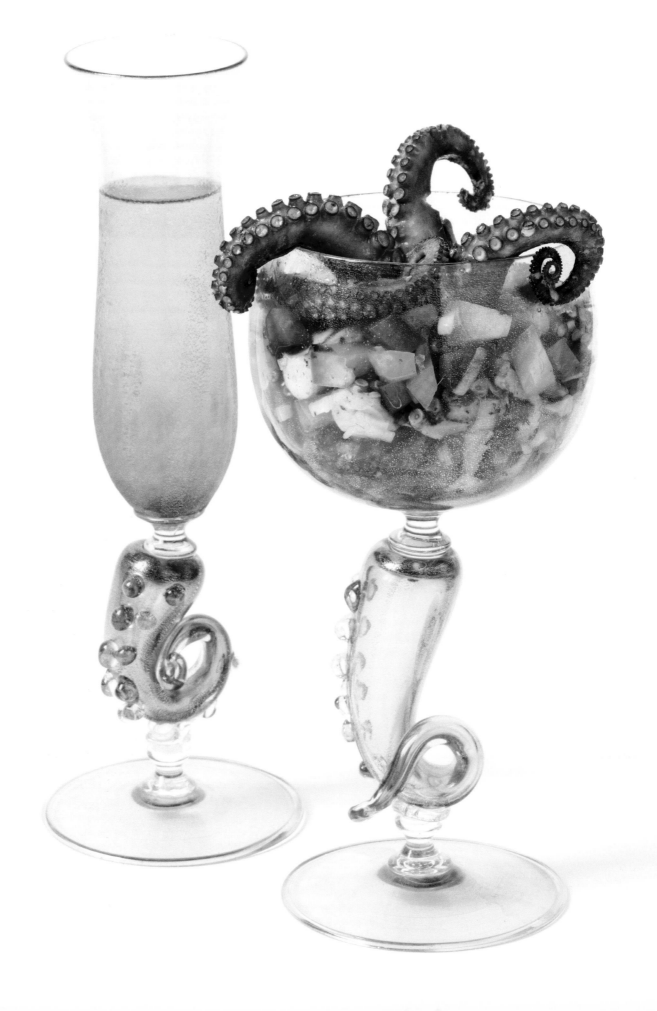

INSALATA DI POLPO
(OCTOPUS SALAD)

There are many varieties of octopus around the world, but the local ones from the Venetian lagoon are among the best you can find. Their distinctive purple and grey colors make them easy to recognize, and their flavor is unbeatable. Commercial frozen octopus loses a lot of its flavor, so always opt for fresh octopus if possible. However, if you happen to catch or buy a very fresh octopus, you'll need to freeze it for a couple of hours before cooking, as this will help to make it tender. Mind the quantities you'll need, as octopus tends to lose almost 50% of its weight once cooked. So, if you want to serve 200gr of finished product you will need to start with 400gr of raw octopus.

FILL
a stock pot with water, add all of the vegetables, and bring to the boil. Keep boiling for 10 minutes to allow the vegetables to release their flavor. This is your court-bouillon.

RINSE
the octopus and put it in the pot of boiling court-bouillon. Bring to the boil again and cook uncovered for exactly 40 minutes. Turn off the heat and cover the pot to allow the octopus to cool in the liquid for a couple of hours.

CUT OFF
the head of the octopus and cut into slices, then cut the tentacles into 3cm segments.

classic Venetian version

CHOP
the tender inner section of the celery into ½cm segments.

COMBINE
the octopus and chopped parsley with the celery. The proportion should be ⅔ octopus to ⅓ celery.

TOSS
everything together, season with salt and pepper to taste, and drizzle with extra virgin olive oil.

Enrica's version

CUT
the bell peppers into small cubes, cut the cherry tomatoes into 8 pieces, chop the chives or spring onions, and place in a bowl.

ADD
the octopus and toss with a drizzle of extra virgin olive oil and a sprinkling of sea salt.

DECORATE
with freshly chopped parsley.

INGREDIENTS

1kg fresh sea octopus

for the court-bouillon
1 medium onion, roughly chopped

2 carrots, roughly chopped

1 clove of garlic, roughly chopped

1 celery stalk, roughly chopped

½ lemon

parsley stems

1 tbsp pepper corns

500ml white wine

for the salad
3 tbsp chives or spring onions

4 tbsp extra virgin olive oil

sea salt and black pepper, to taste

classic Venetian version
chopped parsley

1 celery stalk

Enrica's version
10 ripe cherry tomatoes

1 yellow bell pepper

2 tbsp chives or spring onions

4 tbsp extra virgin olive oil

sea salt, to taste

preparation time
1½ h

serves 4

CAPESANTE O CANESTRELLI GRATINATI

(BAKED SCALLOPS OR CANESTRELLI)

Much smaller than a scallop, the *canestrello* is often tastier—but then in the world of food small is always tastier. Any recipe that you may find for scallops can usually also be adapted for *canestrelli*, although it must be said that, considering their delicate flavor, simpler is better. If you are using *canestrelli* instead of scallops, just use half of the quantities and top each *canestrello* with a teaspoon of the bread crumb mixture instead of a tablespoon.

OPEN

the scallops with a shucking knife (an ordinary butter knife will do if you haven't got one) following the flat side and clean them by pulling off the outer ring of the muscle and then rinsing them under water (you could also ask your fishmonger to do this for you). Repeat the process for all of the shells.

PLACE

the hollow half shells with the muscle on an oven proof tray.

classic Venetian version

PREHEAT

oven to 200°C.

MIX

the breadcrumbs, garlic, and parsley with a fork, drizzle with oil, and season with salt and pepper to taste.

TOP

each half shelled scallop with a tablespoon of the breadcrumb mixture.

BAKE

in preheated oven for 5–6 minutes, or until the breadcrumbs are crunchy and golden.

Enrica's version

PREHEAT

oven to 200°C.

CUT

a slice of orange in 4 and place a quarter on each shell.

ADD

the fresh thyme and grated ginger.

SPRINKLE

with a little oil.

BAKE

in preheated oven for 5–6 minutes, or until a golden ring forms around the scallops.

INGREDIENTS

classic Venetian version

1kg
sea scallops
(or 500gr canestrelli)

250gr
breadcrumbs

4
cloves garlic, chopped

2 tbsp
parsley, chopped

6 tbsp
extra virgin olive oil

salt and black pepper, to taste

Enrica's version

¼ slice of orange
orange zest

1 tbsp
fresh thyme leaves

¼ tsp
grated ginger

preparation time
45 minutes

serves 6

Grille
Fulvio Bianconi for Licio Zanetti
Vetreria Artistica, 1970

previous pages
Flute and goblet from the
Tentacolari series
Maria Grazia Rosin, 2005

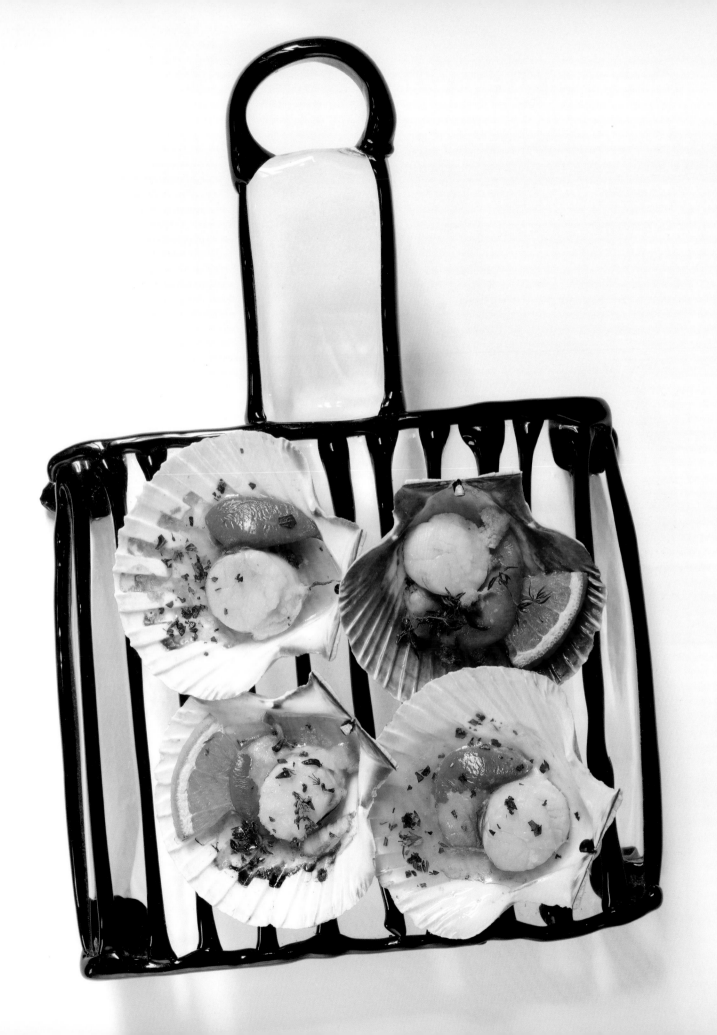

CANOCIE LESSE
(POACHED MANTIS SHRIMP)

Mantis shrimp is the English name for *canocie*, which are also commonly found in the Asian seas.

They are easy to cook and should be served very simply—to be honest, the only complicated thing is learning how to open them once cooked. In my opinion they are much more delicate than most seafood, and the quality of the salt, pepper, and extra virgin olive oil you use for the dressing will make all the difference.

BRING TO THE BOIL

a stock pot of salted water. Once the water begins to boil, drop in the fresh mantis shrimp. When the water comes back to the boil, cook the shrimp for exactly 5 minutes.

STRAIN

the shrimp, and cut the sides of the tail with scissors. Cut the end of the tail in a triangular shape.

VERY CAREFULLY PEEL OFF

the soft top shell, and serve with the underside still attached.

PLACE

on a platter or serving dish and drizzle with a little extra virgin olive oil, salt and pepper to taste, and sprinkle with freshly chopped parsley.

INGREDIENTS

12–16 mantis shrimp

1 tbsp chopped parsley

extra virgin olive oil, to drizzle

sea salt and black pepper, to taste

preparation time
45 minutes

serves 4

Small bowl from the *Battuti* series
Tobia Scarpa and Ludovico Diaz
de Santillana for Venini, 1962

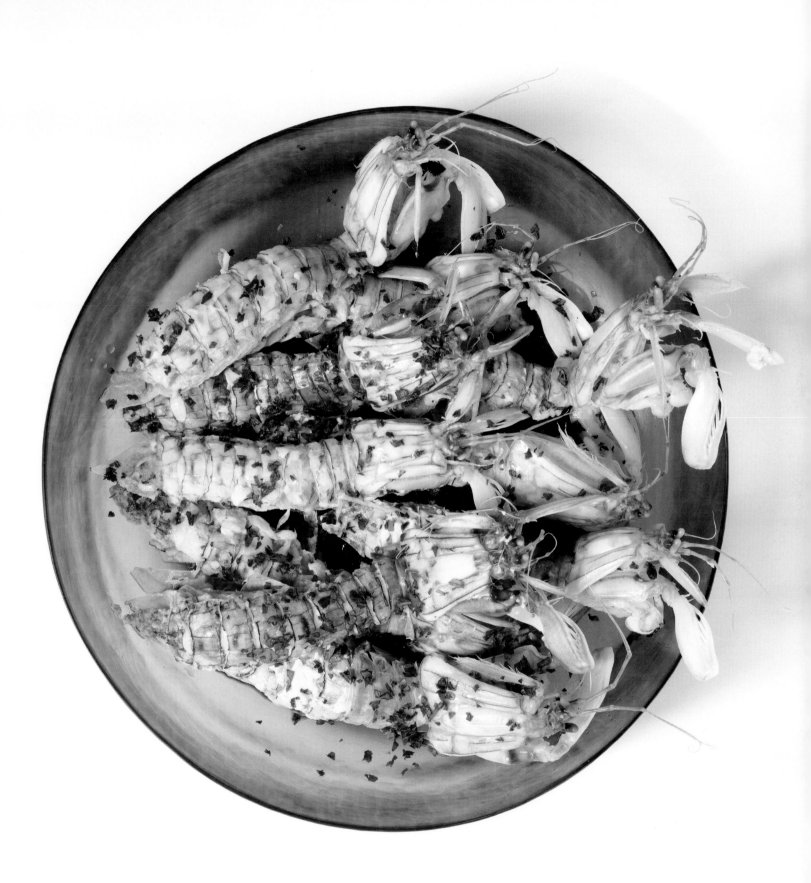

SARDE IN SAOR
(SWEET AND SOUR SARDINES)

Traditionally, fishermen took this dish out to sea and ate it with bread
or *polenta* during their long fishing trips. The vinegar acts as a preservative,
and the onions naturally combat bacteria.
The dish's pine nuts and raisins are a typical example of ingredients that were
imported to Venice through commerce and integrated into traditional dishes.
Although only sardines were originally used for this dish, sophisticated
modernity now allows for *saor* to be made with scampi or langoustine tails,
baby sole fillets, or even *moeche* (soft shell crabs), ingredients that are easier
to find internationally. The preparation is exactly the same.

HAVE

your fishmonger gut the sardines and remove their heads. You can also ask him to butterfly
them.

SOAK

the raisins in warm water.

FINELY SLICE

the onions by hand or in the food processor.

PLACE

extra virgin olive oil in a pan, heat and add onions. Cover the pan and soften
the onions over a low heat for about 20 minutes, or until they start browning.

ADD

the wine and the vinegar, re-cover the pan and continue to cook the onion for another
60 to 90 minutes over a low heat. When finished, they should be very soft and there should
be a little liquid left in the pan. Season with salt and pepper.

LIGHTLY FLOUR

the sardines and deep fry them for 2 minutes on each side in sunflower oil. Place them
on a plate lined with a paper towel to absorb excess oil.

LAYER THE INGREDIENTS

in a serving dish (3–4cm deep). Begin with the onions, then follow with the sardines,
and then sprinkle with raisins and pine nuts. Repeat until all the ingredients are finished,
forming 3–4 layers.

COVER

with cling film and place in your fridge for 5 days. The sardines will absorb all of the flavor
from the other ingredients.

REMOVE

the dish from the fridge one hour before serving.

INGREDIENTS

20
small sardines, very fresh

30ml
extra virgin olive oil

4
white onions,
very thinly sliced

3 glasses
dry white wine

½ glass
white wine vinegar

150gr
raisins, soaked in warm water
for 2 hours

50gr
pine nuts

flour

enough
sunflower oil to fill a 20 cm pan
to a depth of about 4 cm

sea salt and pepper,
to taste

preparation time
1½ h + 5 days in fridge

serves 4

Oval plate
Massimo Micheluzzi, 2013

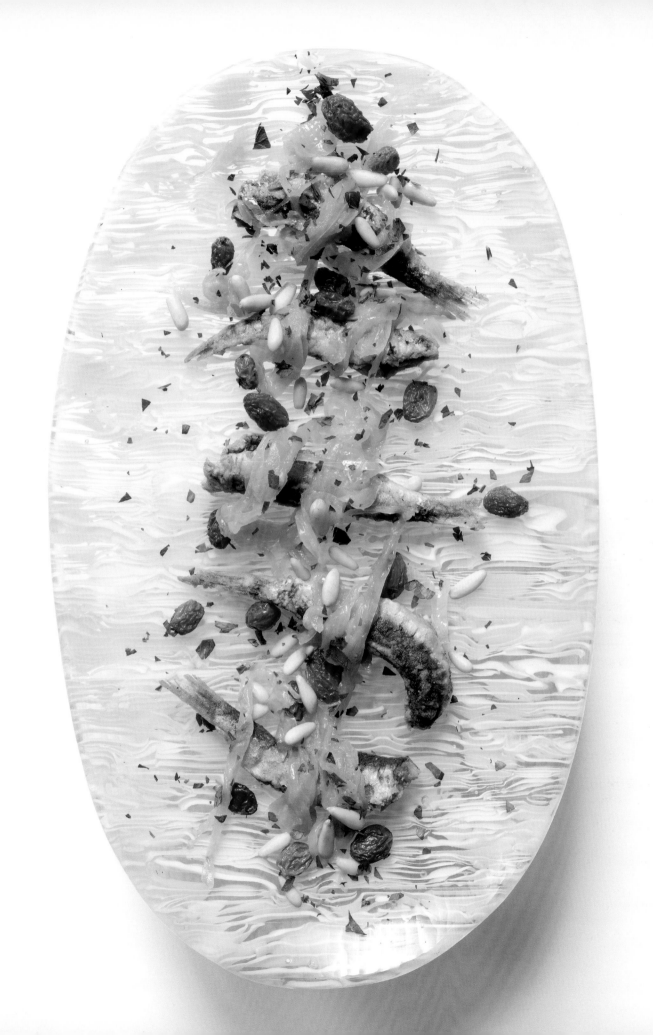

CALAMARETTI E SEPPIOLINE ALLA GRIGLIA
(GRILLED BABY CALAMARI AND CUTTLEFISH)

Baby calamari are relatively easy to find and, apart from the Venetian variety, the most common ones come from Patagonia. When they are fresh they have an intense sea flavor; frozen they can be quite bland and will need more seasoning. Baby cuttlefish are less popular outside of Venice, not because they don't inhabit the oceans, but because there simply isn't much demand. I personally find cuttlefish tastier and more intense than calamari, but this is a very personal opinion.

CLEAN

the cuttlefish: wash them, remove the bone, the eyes, and the beak. Remove the skin and the ink pockets.

INGREDIENTS

4 to 8 baby calamari

4 to 8 baby cuttlefish

20ml extra virgin olive oil

sea salt and black pepper, to taste

1 tbsp freshly chopped parsley

preparation time
30 minutes

serves 4

CLEAN

the calamari: remove the head, and cartilage bone, empty the tube completely, and wash it thoroughly. Cut and keep the tentacles above the eyes, and throw the rest away.

RUB

a little oil on the calamari and cuttlefish.

HEAT

a grilling pan and when very hot add both calamari and cuttlefish and grill for 1–2 minutes on each side. Time will vary depending on the size of the cuttlefish and calamari.

PLACE

on a serving dish, drizzle with a little olive oil, season with salt and pepper, and finish with a sprinkling of freshly chopped parsley.

Small stands and glasses from the *Tentacolari. Gocce di polpo* series
Maria Grazia Rosin, 2005

SALTATA DI CAPELUNGHE
(SAUTÉED RAZOR CLAMS)

Razor clams are very popular in Italy, but less so in many other countries. I've seen them in a few food markets around the world, but they're much larger and less delicate than our small, and sometimes very young, razor clams. They are sometimes so young, in fact, that the shell is still very delicate and they have to be handled carefully when cooking to avoid breaking. All kinds of shellfish can be used for this dish, including mussels and *vongole* or clams, and it is also traditional to mix and serve them together. This dish can be converted to an excellent pasta sauce—just remember to remove all the shells after cooking.

PURGE

the clams of any remaining sand by placing them in bowl of heavily salted water for about 60–90 minutes.

HEAT

oil with garlic in a pan until very hot.

ADD

the clams and half of the parsley.

STIR

well and pour the wine.

COVER

the pan immediately and cook for 3–4 minutes or until all the razor clams have opened. Add black pepper, to taste.

GARNISH

with the remaining parsley.

SERVE

hot with warm rustic bread to mop up the juices.

INGREDIENTS

1kg
razor clams

250ml
white wine

3
cloves of garlic

10gr
parsley

coarse sea salt to purge

black pepper, to taste

5 tbsp
extra virgin olive oil

preparation time
20 minutes + purging time

serves 4

Stand from the *Primavera* series
Barovier & Toso, 1980s

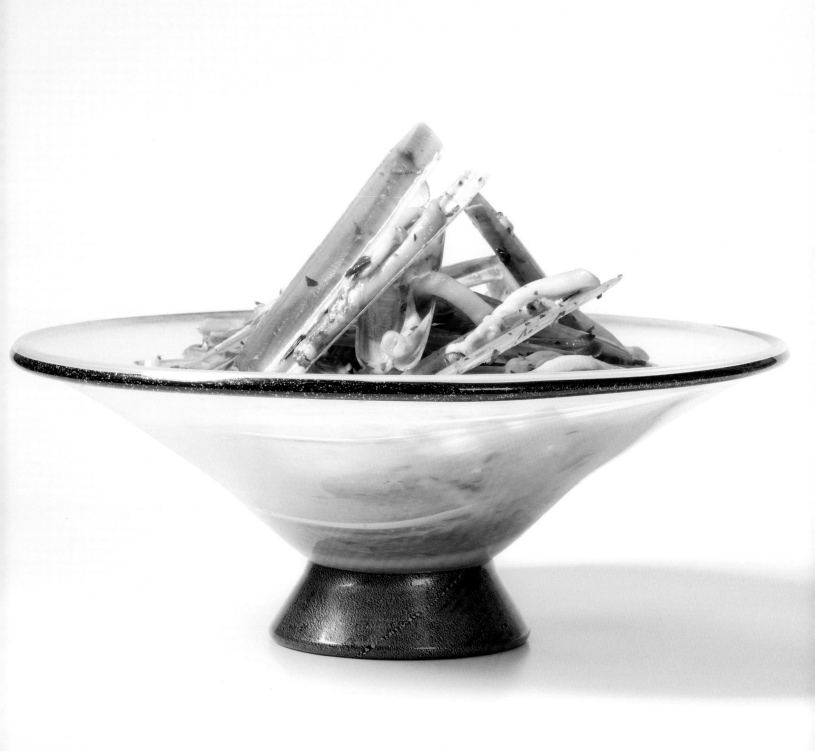

GAMBERETTI CON POLENTA
(SHRIMP WITH POLENTA)

As I also explain in the notes for *schie fritte* (see recipe page 58), the difference between shrimp and *schie* is subtle and due to the consistency of the shell. Shrimp have a tougher shell and need to be peeled in order to be appreciated. This is a very time consuming job, which is why you should not be surprised to pay a bit more for this dish if you go to a serious restaurant that sells the real local product. In fact, during early morning visits to restaurants I've often come across waiters busily engaged in removing the shells—hours before the restaurants are open for service.

BRING
to boil a pot of salted water.

ADD
the baby shrimp and cook for 2 minutes.

DRAIN
and cool completely.

CLEAN
the shrimp by removing heads and shells.

ADD
olive oil and garlic to a frying pan.

WHEN
the oil is hot and the garlic quickly sautéed (be careful not to burn the garlic as it will leave a bitter flavor), add the shrimp and cook for a minute.

ADD
the parsley and season with salt and pepper to taste.

POUR
the soft polenta (see recipe page 138) onto a serving dish, top with the shrimp and sprinkle with some freshly chopped parsley.

INGREDIENTS

500gr
baby shrimp,
carefully cleaned

20ml
extra virgin olive oil

2
garlic cloves

1 tbsp
parsley

sea salt and pepper,
to taste

preparation time
30 minutes

serves 4

Plate
Fratelli Toso, 1970s

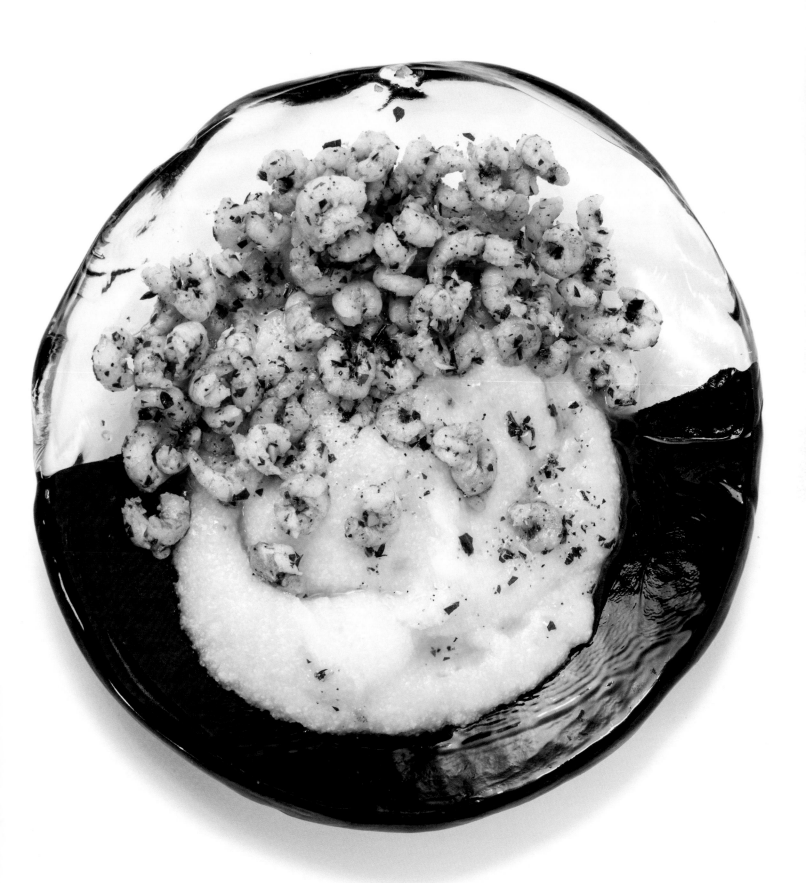

SALTATA DI PEOCI
(SAUTÉED MUSSELS)

This dish can also sometimes be served with fresh or canned tomatoes, which will add extra richness to the sauce. However, this is more of a modern version as tomatoes were not traditionally part of northern Italian cuisine but rather from the warmer regions of the south.

REMOVE
the beards and scrub the mussels clean using a table knife or a steel wool scourer to scrape off all impurities.

HEAT
oil with garlic in a 40cm pan until very hot.

ADD
the mussels and half of the parsley.

STIR
well, add wine, and cover immediately with a lid. Cook for 3–4 minutes or until all of the mussels have opened.

REMOVE
the mussels from the pan using a draining spoon, place in a bowl, and reduce the remaining juices by half on medium heat. At this stage you can add some sliced tomato if you wish. Add black pepper but no salt—the mussels will have released sufficient salty water.

POUR
the sauce over the mussels and garnish with the remaining parsley.

SERVE
hot with warm rustic bread to mop up the juices.

INGREDIENTS

1kg
mussels

250ml
white wine

10gr
parsley, finely chopped

3
cloves garlic

5 tbsp
extra virgin olive oil

black pepper, to taste

preparation time
45 minutes

serves 4

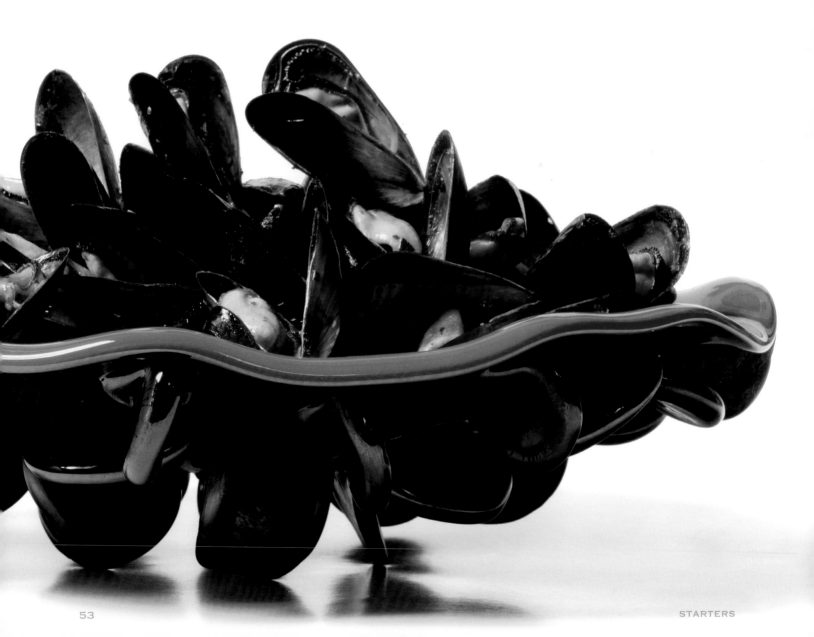

Plate from the *Dysidea.*
Riccio di mare series
Maria Grazia Rosin for CVM, 2009

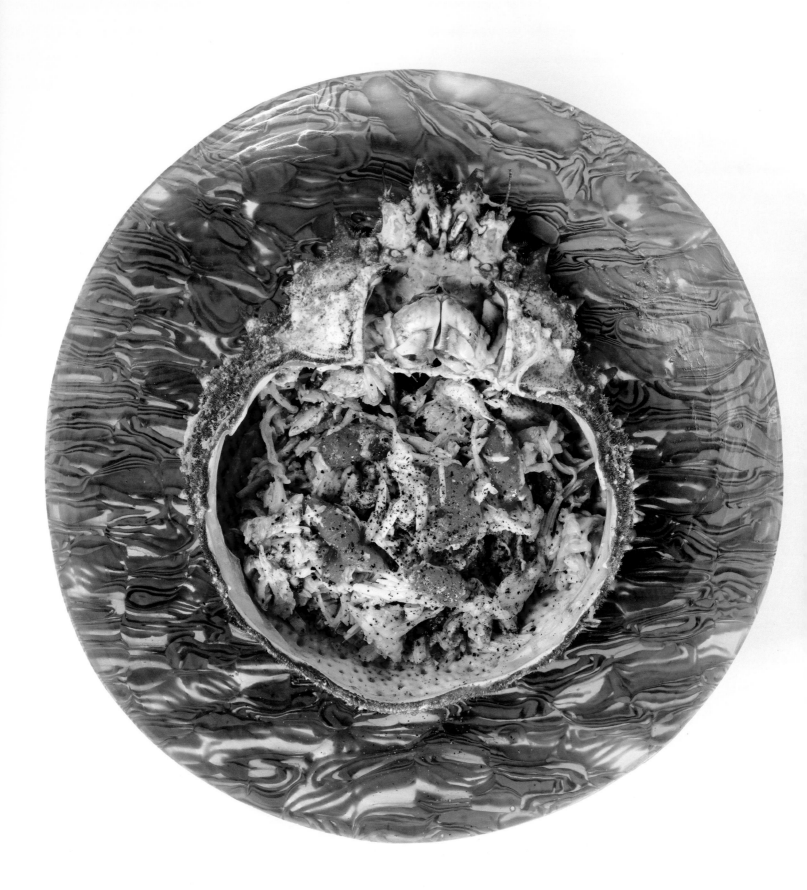

GRANSEOLA
(SPIDER CRAB)

Granseola is incredibly popular in Venice, but I usually only ever eat it in restaurants as it is so laborious to clean that I enjoy it much more when someone else does it for me.

The *granseola*'s very spikey shell, its very long legs, and all the difficult-to-get-at bits where the tasty meat lies hidden make it a really hard slog to prepare. But once you've managed it, the reward is that no other seafood can beat the flavor of a fresh *granseola*. Considering all the hard work involved, you'll want to make the most of your spider crab: when mixed with a light tomato sauce, it becomes a perfect pasta dressing. If you can't find spider crab, a good replacement is crab meat, but make sure you also use the brown meat as that's where most of the flavor lies.

BRING

to the boil a large pot of salted water and once boiling add the spider crab and cook for 5 minutes.

TURN

the heat off and let it rest in the water for 10 minutes before draining.

USING

a nutcracker and a toothpick or a wooden skewer remove all the meat from the legs and the head. Do not discard the brown meat.

PLACE

all the spider crab meat into the empty shells.

SEASON

with olive oil, a little lemon juice, and salt and pepper to taste.

INGREDIENTS

4
spider crabs

4 tbsp
extra virgin olive oil

juice of ½ lemon

sea salt and black pepper,
to taste

preparation time
1h 10 minutes

serves 4

Round plate
Massimo Micheluzzi, 2013

MOECHE FRITTE
(FRIED SOFT SHELL CRABS)

Moeche, or soft shell crabs, are a real delicacy, difficult to find (they are available only three times a year—during Lent and September for the males and May–June for the females), and frighteningly expensive (anything between €50 and €70 per kilo). Why? Simple—crabs only molt once a year and the molting process only lasts 24 hours. So fishermen, armed with enormous nets, fish hundreds of them at a time, and then they individually select only those with the softest shell. It's this intensive labor that adds to the cost of the final product. Though very popular in Asian cuisine (Japanese make incredible rolls with soft shell crab) and much less prevalent in European cuisines, these soft shell crabs are much sought after in the Venetian lagoon and are considered a jewel of our gastronomy.

IF YOU USE

live soft shell crabs, beat the eggs in a bowl and place the live crabs in the mixture for a couple of hours. They will eat the egg and plump up a bit.

AFTER

the 2 hours, remove the crabs from the egg mixture, lightly flour them, and deep fry them in the sunflower oil (heat to 170°C).

IF YOU USE

frozen crabs then defrost them, pat them dry, lightly flour, and deep fry them (they must be very carefully dried as any residual water on the crabs will react with the boiling oil and you might get burned).

FRY

the crabs until crisp (3–4 minutes).

SEASON

with salt to taste and serve hot.

INGREDIENTS

8 to 12 soft shell crabs from the lagoon, still alive
(or 4 defrosted and carefully dried Asian soft shell crabs; these are about 3 times the size of a Venetian moeca)

1 to 2
eggs
(only if you are using live crabs)

60gr
plain white flour

enough
sunflower oil to fill a pan to a depth of about 5cm (quantity will vary depending on the size of the pan)

sea salt, to taste

preparation time
30 minutes + resting time

serves 4

Mercurio 2179 plate
Ottavio Missoni for Arte Vetro
Murano, 1988–1989

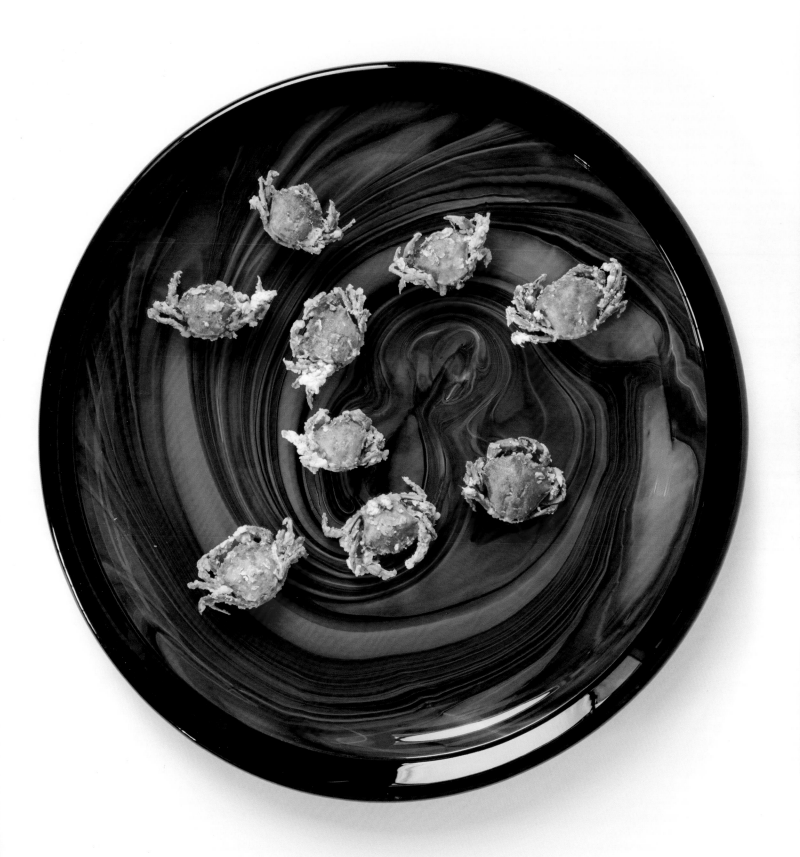

SCHIE FRITTE
(FRIED LAGOON SHRIMP)

There is a difference between *schie* and shrimp. The two may look and even normally taste very much alike, but when they are eaten fried and whole there is a distinct difference. *Schie*, also known as Gray Shrimp and very common in the Baltic sea, are younger, their shell more tender than that of shrimp, and this makes them pleasurable to the palate. The shells of the shrimp are tougher, and their antennae can be prickly and much less pleasant to eat. Also, shrimp turn red when cooked while *schie* remain a less attractive gray. This recipe also works very well with whitebait (they might be easier to find, and are also very common in Venice).

LIGHTLY FLOUR
the *schie* or whitebait, removing any excess flour.

DEEP FRY
the *schie* or whitebait for 2–3 minutes in 5cm of hot (170°C) oil until crisp and cooked through.

REMOVE
from the pan with a draining spoon and place on a plate lined with paper towel to absorb excess oil.

SPRINKLE
generously with salt and serve hot.

INGREDIENTS

200gr
of fresh lagoon shrimp
(or whitebait)

75gr
flour

enough
sunflower oil to fill a pan
to a depth of about
5cm (quantity will vary
depending on the size
of the pan)

2–3 pinches
of sea salt

preparation time
30 minutes

serves 4

Stand
Seguso Vetri d'Arte, 1930s

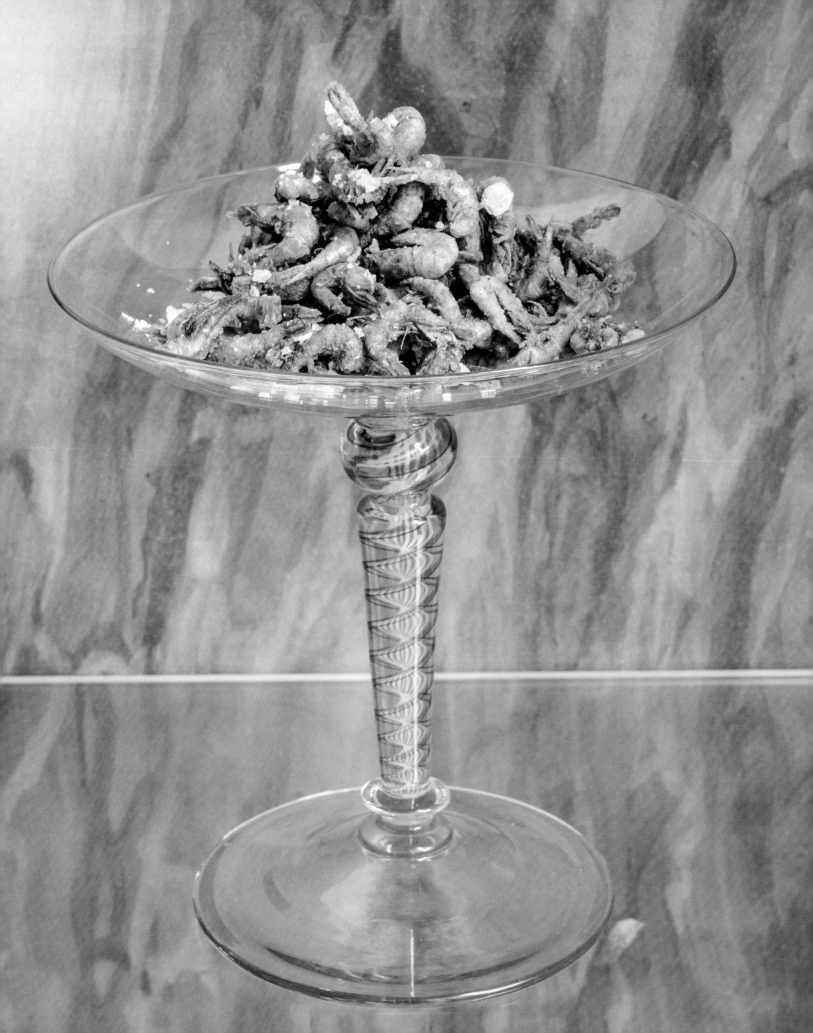

FIRST COURSES

LA PASTA
(COOKING PASTA)

Of course when we think of Italy we immediately think of pasta. This pillar of Italian culinary culture is always served as a first course and rarely as a main course unless one is in a hurry.

Though cooking pasta is simple, it has its rules. The first and most important is to choose the right brand. De Cecco is easily found in most supermarkets and is always good, as is the Garofalo brand, which is now being stocked more and more often by delis. In some of the large grocers', you will often find Martelli pasta (in its bright yellow packaging), which is more porous and has great consistency. My favorite pasta is still Verrigni, beyond all others. The best area for growing wheat in Italy is Gragnano, so if the packet states "Pasta di Gragnano" the quality is usually guaranteed. You will mainly find these premium pastas in delicatessens, and they are more expensive than the more commercial ones.

Two other things to look out for on the packaging are:
- *Trafilata al bronzo*: this means the pasta has been shaped with a bronze mold, which makes the pasta more porous.
- *Essicatura lenta*: this means the pasta has been dried slowly, which allows the wheat to ferment slightly and creates a more intense flavor.

Quick tips for pasta:
- Portions: calculate 100gr per person as a starter and 120gr per person as a main course.
- Use lots of water. Pasta needs a lot of water in order to cook properly. As it contains a lot of starch, if you don't cook it in sufficient water it will turn gluey and clump together. The rule of thumb is 1lt of water for every 100gr of pasta you cook—so 500gr of pasta will need 5lt of water. If you follow this rule, you will never need to add oil to the cooking water.
- Be heavy-handed with the salt. The water should be as salty as the Mediterranean sea. Pasta itself does not have a lot of flavor as it is only made with water and durum wheat, so it needs salt to bring out the flavor. Use a natural rock sea salt (Maldon or similar), and never rinse pasta after cooking it.
- Keep your pasta *al dente* for a much more pleasant consistency. Check for recommended cooking times on the package, but taste a minute before the recommended time.
- Coat, don't drown. Pasta should be coated by the sauce and should not "swim" in it…

INGREDIENTS

**100gr
pasta**

**1lt
water**

**10g
coarse sea salt**

preparation time
varies depending on the kind and shape of pasta

serves 1

IL VERO RISOTTO
(COOKING RISOTTO)

This is my favorite Italian dish and probably one of the most difficult
to master. Unfortunately, only experience will help here. I will now give
you the main guidelines, but only practice makes perfect. There are many
different kinds of risotto and unfortunately they all work differently.
As you probably already know, a lot of Venetian dishes are made with
very humble ingredients as in the past meat was a luxury that people could
only afford a couple of times a month.
Vegetables were locally produced and the rice used for risotto (Vialone
Nano) was cultivated in the area of Verona, so in order to make the risotto
dish richer and more nutritious all sorts of vegetables were added.
Remember that the doses given here per person should always be
augmented by an extra little handful "for the pot".
The base of your risotto should always be the same: equal parts of butter
and olive oil, onion, and white wine. Let the onion cook in the butter and oil
until clear, then add the white wine and simmer until it has evaporated,
the longer the better. Then build from that.
Quick tips for risottos:
- Choose your rice carefully. Never use Arborio rice. I know it's the most
popular, but it's by far the least suited for risottos. Use Carnaroli or Vialone
Nano, both of which are easily available in different brands at main
supermarkets.
- Use a complementary stock. It is best to make your own, but if you are in
a hurry you can simply use hot water and stock cubes, which most people
do now. If you're preparing fish or seafood risottos, use a fish stock. If you're
using shellfish, such as mussels, open them as you would for seafood pasta
and then use the juices to cook the risotto.
- Carefully prepare your ingredients. For any risotto, you will have to cook
the ingredients you choose before adding the rice. For example, if you make
a zucchini risotto, first fry the zucchini with the onions until they are brown
and thoroughly cooked before you add the rice and continue the risotto.
If you add the zucchini at the end your risotto will tend to be rather tasteless
and bland.

A couple more rules for seafood risotto:
1) Never add butter or Parmesan cheese. Add lots of parsley and either some
extra virgin olive oil or a couple of tablespoons of heavy or double cream,
or crème fraiche.
2) Only add the seafood at the end, as otherwise it will be overcooked.

INGREDIENTS

70gr
Carnaroli rice
+ 1 small fistfull of rice
for the pot

250ml
stock

1 tbsp
onion, finely chopped

25ml
dry white wine

1 tbsp
extra virgin olive oil

preparation time
18–20 minutes

serves 1

FUMETTO DI PESCE
(FISH STOCK)

POUR
the extra virgin olive oil in a large pot and when hot add the fish bones and all the other ingredients.

COOK
for at least 20 minutes with no liquid to allow the bones to seal properly and the vegetables to release the maximum of flavour.

FILL
the pot with water and white wine.

BRING
gently to the boil. Cover with a lid and simmer on low heat for 1 hour.

REMOVE
the bones and vegetables using a strainer.

FILTER
the stock with a chinois, or fine-mesh strainer, and place the stock in a smaller pan.

SEASON
to taste.

INGREDIENTS

50ml extra virgin olive oil

1kg rockfish or fish bones and heads

1 large carrot, roughly cut

1 large onion, roughly sliced

1 celery stick, roughly sliced

1 bay leaf

1 clove garlic

a few stalks of fresh parsley

1 lemon cut in half

20 whole peppercorns

500ml dry white wine

sea salt to taste

3lt water

preparation time
1h 20 minutes

BRODO VEGETALE
(VEGETABLE STOCK)

IN A STOCK POT
add all the chopped vegetables and other ingredients, and a little extra virgin olive oil and cook for 30 minutes before adding the water.

ADD
water.

BRING
gently to the boil. Cover with a lid and simmer on low heat for at least 1½ hours.

FILTER
the stock with a chinois, or fine-mesh strainer, and place the stock in a smaller pan.

SEASON
to taste.

INGREDIENTS

2 large onions, sliced

2 large carrots, sliced

3 celery sticks, sliced

2 bay leaves

20 pepper corns

stalks of fresh parsley

1 clove garlic

sea salt to taste

3lt water

preparation time
2h

BRODO DI POLLO O DI CARNE
(CHICKEN OR MEAT STOCK)

POUR
the extra virgin olive oil in a large pot and when hot add the bones.

COOK
for 5 minutes to allow the bones to seal properly. Lower the temperature, add the vegetables and cover with a lid. Let simmer for 20 minutes to allow the vegetables to release the maximum of flavour.

FILL
the pot with water and bring gently to the boil.

COVER
with a lid and let simmer on low heat for at least 3 or 4 hours (the longer the better).

FILTER
the stock with a chinois, or fine-mesh strainer, and place the remaining stock in a smaller pan.

LET
the stock rest until it has completely cooled.

REMOVE
the fat that you will see on the surface with a slotted spoon.

SEASON
to taste.

INGREDIENTS

1kg meat bones or chicken

1 large onion, sliced

2 large carrots, sliced

2 celery sticks, sliced

1 bay leave

20 pepper corns

50ml extra virgin olive oil

sea salt, to taste

3lt water

preparation time
3h

BIGOLI IN SALSA
(SPAGHETTI WITH ONION AND ANCHOVIES)

This incredibly simple and humble dish is a delight and will reconcile you with anchovies if you happen to be one of those people who find them too strong. The sweetness of the onion balances out the saltiness of the anchovies to create a delicate, irresistible taste. There are many different kinds of anchovies, but for this dish you should use salt-packed ones. As it's not very easy to find the very best Spanish or Portuguese salt-packed anchovies, you can use any good quality anchovies that have been salt packed and jarred. Bigoli is a traditional, handmade, whole-wheat pasta from Veneto that people used to make at home. Nowadays it is sold commercially and only a handful of restaurants or families make bigoli by hand. A special machine is used to shape the dough into fragrantly delicious long, thick, spaghetti-like noodles. If you can't find bigoli, normal spaghetti will do just as well.

SLICE

the onions very finely by hand, in a food processor, or with a mandolin.

HEAT

oil in a frying pan and, when warm, add onions and cover. Cook over low heat for about 20–25 minutes, or until soft (do not brown). If they release too much water, cook for a little longer.

JUST BEFORE

the onions begin to brown, add the white wine and continue cooking on very low heat for a further 60–90 minutes. When finished, they should be very soft with a little liquid still in the pan. If all the water has evaporated and the onions are still not soft enough, add 1 or 2 glasses of water and continue cooking on very low heat. The onions should be almost caramelized but still have some liquid left.

WHILE

the onions are cooking, remove all bones from the anchovies and mash them with a fork.

ONCE

the onions are ready, add the mashed anchovies and chopped parsley to the pan. Continue to cook until the anchovies are all but disintegrated.

COOK

the bigoli in salted water boiling according to instructions until *al dente*.

DRAIN

the pasta and toss it in the frying pan containing the onions, anchovies, and parsley. Season with pepper to taste.

PLACE

in a serving dish and garnish with freshly chopped parsley.

INGREDIENTS

2
medium onions

400gr
bigoli (whole wheat spaghetti)

8
good quality anchovies
(or 4 to 6 salt-packed sardines, number will depend on size)

2 tbsp
chopped parsley

6 tbsp
extra virgin olive oil

250ml
dry white wine

sea salt and pepper,
to taste

preparation time
45 minutes

serves 4

Bowl
Flavio Poli for Seguso
Vetri d'Arte, 1955

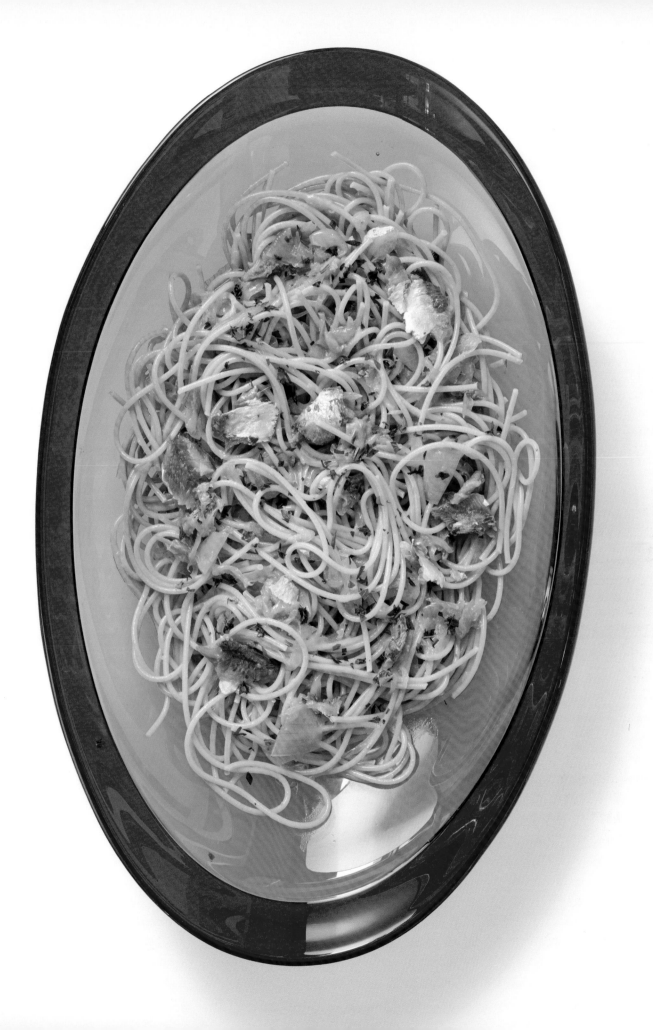

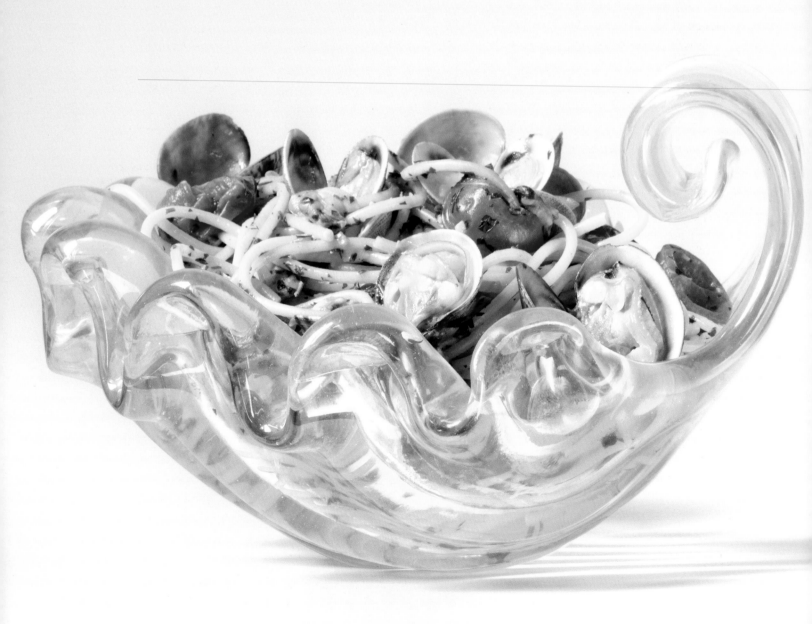

SPAGHETTI ALLE VONGOLE
(SPAGHETTI WITH CLAMS)

When properly done, this is one of my favorite pasta dishes. Of course, *vongole* or clams from the Lagoon are the best, but even in Venice there are only a few fishmongers I'll buy them from as there are many "fake" *vongole*, even at the Rialto market. Mussels and cockles are a good alternative if they are fresh. I like the wonderful color and flavor that a few cherry tomatoes add, but the "white," or tomato-less, version is more traditional.

PURGE
the clams of any remaining sand by placing them in a bowl of heavily salted water for 60–90 minutes.

HEAT
the extra virgin olive oil in a pan until very hot.

ADD
the clams and white wine to the pan.

COVER
and cook for 3–4 minutes, or until all the clams have opened.

REMOVE
them from the pan using a slotted spoon, shell them, and set aside. Only keep a few in their shells to decorate. Leave the juices in the pan.

BRING
salted water to the boil and begin cooking the pasta.

PLACE
the pan with the juices back on the heat and add the chopped parsley, and garlic (and the halved cherry tomatoes if you are using them).

REDUCE
heat to medium low and reduce the sauce.

COOK
the pasta only until very *al dente*, strain, add to the pan and finish cooking it in the sauce. Keep the cooking water of the pasta. If the pasta is still too *al dente* once all the juices and sauce have been absorbed, add a ladle of the water the pasta was cooked in, and cook for another minute or so.

ADD
the clams only once the pasta is cooked to your taste, then give everything a final toss.

SERVE
with a drizzle of extra virgin olive oil, add black pepper, and garnish with chopped parsley.

INGREDIENTS

1kg
fresh clams

400gr
spaghetti or linguine

250ml
white wine

15gr
parsley, chopped

2
cloves garlic, chopped

10–12
halved cherry tomatoes (optional)

4 tbsp
extra virgin olive oil

coarse salt and black pepper, to taste

parsley to garnish

preparation time
30 minutes + purging time

serves 4

Shell-shaped bowl
Ercole Barovier
per Barovier & Toso, 1942

SPAGHETTI ALLA BUZARA
(SPAGHETTI WITH SCAMPI IN SPICY SAUCE)

Scampi are incredibly delicate and, though completely different in appearance and taste, are often confused with prawns. The scampi's long claws give this dish its richly textured taste, but, because they are difficult to find in many countries, replacing them with prawns is virtually a given. If you do replace them with prawns, make sure to use whole prawns—without the heads you'll miss out on most of this dish's incredible flavor.

REMOVE

the head of the scampi and set aside.

SHELL

the tails and set aside.

HEAT

the extra virgin olive oil in a pan and add the garlic, chili, and half the parsley.

COOK

for a couple of minutes.

ADD

the scampi heads, cook for a few minutes with the lid (the longer the better, but careful not to burn the garlic), add the white wine and let evaporate.

ADD

the tomato passata and season with sea salt and pepper.

COOK

for at least 20 minutes to allow the sauce to absorb all the flavor of the scampi heads. Before removing the scampi heads, squash them thoroughly with a wooden spoon in order to extract as much of the juices as possible, which will give extra flavor.

BRING

a large pot of salted water to the boil and cook the pasta until *al dente*.

DRAIN

the pasta but keep a cup of the water it was cooked in should you need it to moisten the finished dish.

ADD

the pasta to the pan with the shelled tails. This will only take a minute to cook, and should remain moist. Toss thoroughly.

GARNISH

with the remaining chopped parsley and season with black pepper, to taste.

INGREDIENTS

12
fresh scampi

4 tbsp
extra virgin olive oil

1
clove garlic, whole

3 tbsp
parsley, finely chopped

500ml
tomato passata

1 glass
dry white wine

1 pinch
chili powder

400gr
spaghetti

sea salt and black pepper,
to taste

preparation time
40 minutes

serves 4

Bowl
Lino Tagliapietra, 1989

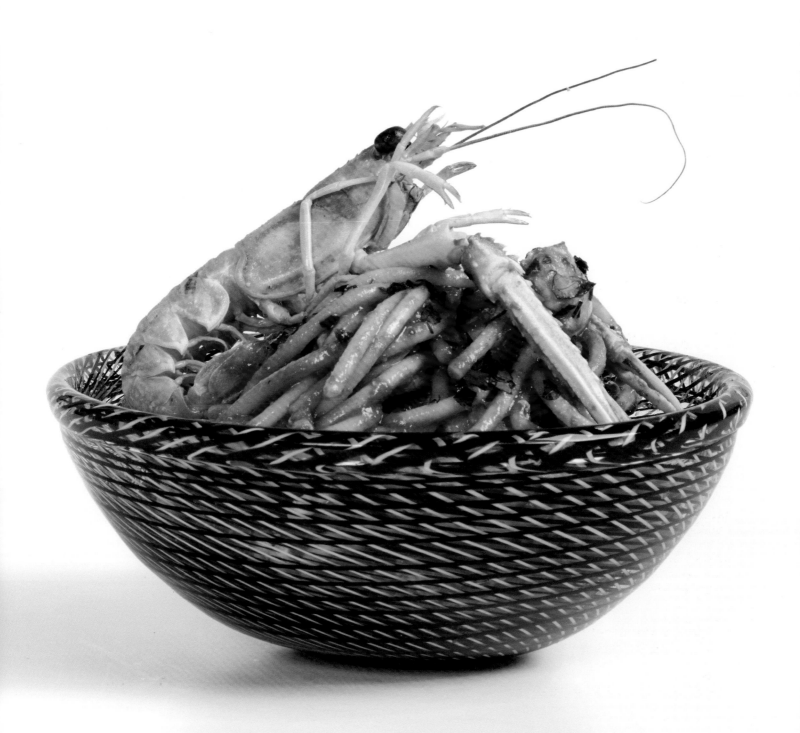

SPAGHETTI CON LE SEPPIE AL NERO
(SPAGHETTI WITH CUTTLEFISH IN INK)

The black ink is the cuttlefish's defense system—if they're in danger they will release it and simply disappear behind a black cloud. This very humble dish (cuttlefish is very common in most seas) originated from the idea that people could not afford to waste any food at all, so the cuttlefish's ink sac was also used, thus giving the dish a very distinctive flavor. In many countries cuttlefish is sold already cleaned, but you can purchase packets of cuttlefish ink which is also used to color pasta. Traditionally we would use the very large, tougher cuttlefish to make this dish, while the smaller, more tender cuttlefish would be used for grilling (see page 46). A large cuttlefish will take much longer to cook. Small ones will be ready in no more than 30 minutes. The cuttlefish black ink can also be used as a base for a risotto or simply eaten with polenta.

CLEAN
the cuttlefish: remove the bone, eyes, and beak. Remove the ink sac and set aside.

CUT
the cuttlefish into strips (2cm wide).

SAUTÉ
the onion and garlic in extra virgin olive oil for 10–15 minutes, or until soft.

ADD
half of the white wine and cook on medium heat until all the wine has evaporated (about 5 minutes).

ADD
the sliced cuttlefish and let it sear for 2–3 minutes. Add the ink sacs, parsley, passata or tomato paste, the water, and the rest of the wine.

COOK
thoroughly on a low heat for about an hour, or until the cuttlefish is tender and the sauce has thickened. For very large cuttlefish allow for more cooking time.

SEASON
with good quality sea salt and lots of freshly ground black pepper.

BRING
a large pot of salted water to the boil, then add the spaghetti and cook until *al dente*.

DRAIN
the pasta and add to the cuttlefish and its sauce.

STIR
thoroughly and serve hot. Garnish with a little finely chopped parsley, and ground black pepper to taste.

INGREDIENTS

1kg
cuttlefish

ink sacs from the cuttlefish

1
medium onion

250ml
white wine

1
clove garlic, chopped

60ml tomato passata
(or 1 tsp tomato paste)

250ml
water

chopped parsley

sea salt and black pepper,
to taste

400gr
spaghetti

4 tbsp
extra virgin olive oil

fresh ground black pepper,
to taste

preparation time
1h 45min

serves 4

Plate
Murano production, 1980s

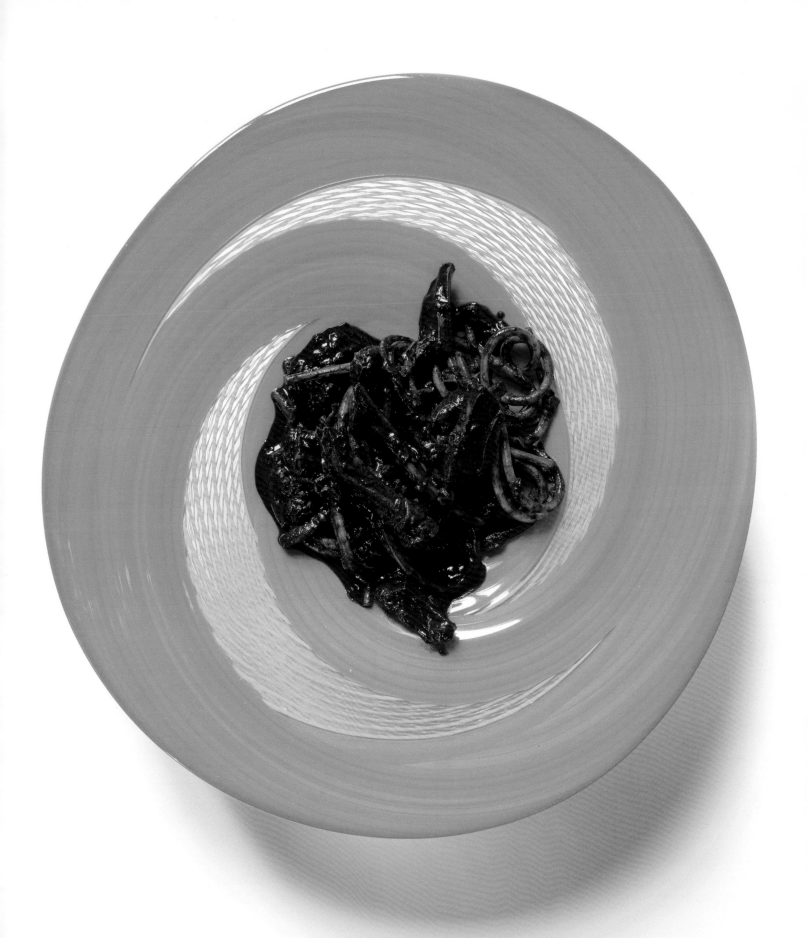

RISOTTO DI PESCE
(FISH RISOTTO)

In the old days, Venetians would prepare this risotto by using baked or poached fish left over from the day before. Leftover fish carcasses would also be used to make fish stock. Now, restaurants use all kinds of offcuts and leftovers to create this dish. As in all risottos the secret is in the stock (see page 64 for fish stock). Read the Introduction to Risotto section (see page 63) very carefully, and don't be put off by the myth that the risotto is a complicated dish. Unlike traditional risottos, it is not recommended that you add butter or Parmesan. Instead, crème fraiche or extra virgin olive oil can be added at the very end to achieve the same creamy smooth finish.

ADD
2 tbs extra virgin olive oil to a pan and heat. Once heated, add mussels and clams, and allow to open (see page 52).

REMOVE
mussels and clams from their shells and set aside.

SAUTÉ
the onion in 2 tbsp extra virgin olive oil on very low heat, lid on, until soft. As soon as the onion starts to brown, add the white wine and cook until it evaporates (the longer the better).

ADD
the rice and toast for 2–3 minutes, or until it becomes slightly translucent.

LADLE
boiling stock to cover the rice and stir continuously to release the starch from the rice.

ADD
more stock, one ladle at a time, as the rice absorbs it, and stir continually.

AFTER
about 15 minutes, stir in the prawn tails, mix in thoroughly, and continue stirring.

COOK
for about 5 more minutes, or until the rice is cooked through and the risotto has a creamy consistency (cooking times will vary depending on the type of rice you use).

WHEN
the rice is cooked, stir in the broken up baked fish, the mussels, and the clams.

REMOVE
from the hob, add 1 tbsp of crème fraiche per person, or the same amount of extra virgin olive oil. Stir vigorously.

GARNISH
with grilled scallops, lightly poached scampi and prawns, freshly chopped parsley and black pepper.

INGREDIENTS

320gr Carnaroli rice

200gr deboned baked white fish (you can use sea-bass, sea-bream, scorpion fish, or any fish you find at the markets)

200gr mussels

200gr clams

8 prawn tails + 4 whole prawns

4 scallops

4 scampi

1.5lt fish stock

1 medium onion, finely chopped

125ml white wine

4 tbsp extra virgin olive oil

4 tbsp crème fraiche (or 4 tbsp extra virgin olive oil)

parsley, finely chopped

sea salt and black pepper, to taste

preparation time
1h 30 min

serves 4

Plate with fishes
Alfredo Barbini
for Gino Cenedese, 1950

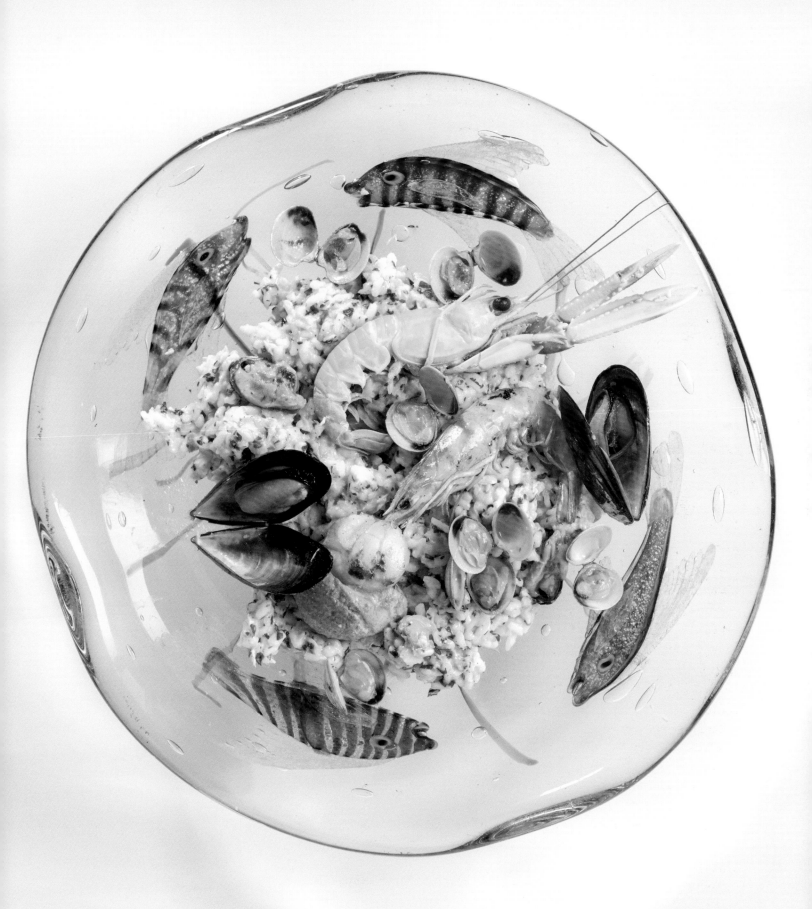

RISOTTO CON SALSICCIA E RADICCHIO
(SAUSAGE AND RADICCHIO RISOTTO)

Treviso radicchio, the very particular and prestigious vegetable, generally used for this recipe, is only available during the winter months and is a very labor intensive product. It would take far too long to explain the whole production process (see p. 131 for more information), but suffice it to say that Treviso's specific microclimate and its natural water sources mean that it is virtually impossible to produce this variety of chicory anywhere else in Italy. Though it is extremely difficult to find Treviso radicchio outside of Italy, it can be replaced in this recipe by cabbage. The cooking process is identical except for the fact that cabbage takes a lot longer to cook, and white wine should be used instead of red. Italian pork sausages are different in the various regions and cities, so look for very pure pork sausage when trying this great dish.

WASH

the radicchio thoroughly and cut horizontally into thin slices, roots included. If you are using cabbage cut very finely and discard the very hard inner part.

CUT

the sausages into small chunks after pealing them.

SAUTÉ

the onion in the extra virgin olive oil on very low heat, lid on, until soft (the longer you cook the onions the better).

AS SOON AS

the onion begins to brown, add the radicchio, sausage, and a little salt, then cook until the mixture softens and releases its liquid.

ADD

the wine and cook until it evaporates. Then add the rice, stir well, and toast for 2–3 minutes, or until it becomes slightly translucent.

LADLE

boiling stock to cover the rice and stir continuously to release the starch from the rice. Add more stock, one ladle at a time, as the rice absorbs it, and stir continually.

COOK

for about 20 minutes, or until the rice is cooked through and the risotto has a creamy consistency (cooking times will vary depending on the type of rice you use).

REMOVE

from the hob, add the butter and Parmesan, and stir vigorously until you get a creamy consistency.

GARNISH

with freshly chopped parsley and season with sea salt and black pepper.

INGREDIENTS

350gr
Carnaroli rice

4 Treviso radicchio heads
(or 1 medium cabbage,
about 800gr)

300gr
pure pork Italian sausage

1.5lt
chicken stock

150ml
dry red wine (or white wine
if using cabbage)

1
medium onion,
finely chopped

50gr
butter

100gr
Parmesan cheese

3 tbsp
parsley, finely chopped

4 tbsp
extra virgin olive oil

sea salt and black pepper,
to taste

preparation time
1h

serves 4

Filigree plate
Barovier & Toso, 1980s

RISI E BISI
(PEA RISOTTO)

This is one of the most traditional Venetian risottos and one that should only be made when fresh peas are available, as the success and authenticity of the dish depend very much on the fact that you also use the pods. That's right, the pods. When dealing with older traditional recipes, you need to bear in mind that food was not as abundant a commodity as it is today, and people could not afford to waste a single scrap. Everything had to be used—pea pods included! Of course many people now use frozen peas and make it all year round, but it never tastes the same. There is nothing even remotely difficult about this dish. All you need is a good Mouli and you're off.

SHELL
the peas and keep both peas and pods, separated.

BRING
a stock pot of salted water to the boil then add the pods and cook for 5 minutes. The salt will help keep them nice and green.

STRAIN
the pods, rinse them in cold water, and puree them through a Mouli grater a little at a time. All that you'll be left with is a little of the pods' "gristle" in your Mouli.

COLLECT
the pureed pod in a bowl and set aside.

INGREDIENTS

320gr
Carnaroli rice

1.5lt
chicken or vegetable stock

1kg
fresh peas in their pods

1
small onion, finely chopped

150ml
dry white wine

1 tbsp
extra virgin olive oil

50gr
butter

100gr
Parmesan cheese

3 tbsp
parsley, finely chopped

freshly ground black pepper,
to taste

preparation time
1h

serves 4

SAUTÉ

the onion in extra virgin olive oil on very low heat, lid on, until soft. As soon as the onion starts to brown, add the white wine and cook until it evaporates (the longer you cook the onions the better).

ADD

the peas, stir well, and cook for 5 minutes.

ADD

the rice, stir well, and toast for 2–3 minutes, or until it becomes slightly translucent.

LADLE

boiling stock to cover the rice and stir continuously to release the starch from the rice.

ADD

more stock, one ladle at a time, as the rice absorbs it, and stir continually. Also add the purée of the pods to the rice.

COOK

for about 20 minutes, or until the rice is cooked through and the risotto has a creamy consistency (cooking times will vary depending on the type of rice you use).

REMOVE

from the hob, add the butter and Parmesan, and stir vigorously until you get a creamy consistency. Garnish with freshly chopped parsley and season with freshly ground black pepper, to taste.

Totem
Massimo Nordio, 2004

RISOTTO DI ZUCCHINE
(ZUCCHINI RISOTTO)

My father was an amazing cook and I loved his zucchini risotto more than any other risotto he ever made. The quality of the zucchini is very important: they should be small and packed full of flavor. When in Venice I try to use the zucchini from the island of Sant'Erasmo, but other small zucchini are also fine. It is very important to cook the zucchini and onions for a long time, until they're almost completely disintegrated and have caramelized. This is what brings out all the flavor. If the zucchini come with their flowers attached, then you can julienne the flowers and stir them in at the end for extra color and moisture, or fry them and use them for garnish.

SLICE
the onions and zucchini very finely in a food processor.

COOK
them in 30gr butter and 2 tbsp of extra virgin olive oil until soft.

KEEP
covered over a low heat until they have released their juices, begin to turn golden brown, and all the liquid has evaporated. This should take about 1 hour.

ADD
the rice and let it toast for 2–3 minutes, or until it becomes slightly translucent.

LADLE
boiling stock to cover the rice and stir continuously to release the starch from the rice.

ADD
more stock, one ladle at a time, as the rice absorbs it, and stir continually.

COOK
for about 20 minutes, or until the rice is cooked through and the risotto has a creamy consistency (cooking times will vary depending on the type of rice you use).

REMOVE
from the hob, add 30gr butter and about half the Parmesan, and stir vigorously until you get a creamy consistency.

DEEP FRY
4 zucchini flowers and use to decorate the risotto (see page 96 for how to deep fry them).

GARNISH
with freshly chopped parsley and more Parmesan, then season with sea salt and black pepper, to taste.

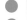

INGREDIENTS

800gr
baby zucchini

4
zucchini flowers (optional)

2
medium onions

5 tbsp
extra virgin olive oil

320gr
Carnaroli rice

about 1.5lt
stock
(chicken recommended, but a good vegetable stock is also very good)

50gr
Parmesan cheese, grated

60gr
butter

sea salt and black pepper, to taste

parsley to garnish

preparation time
45 minutes

serves 4

Plate
Design Laura Diaz de Santillana, made by Simone Cenedese, 1990s

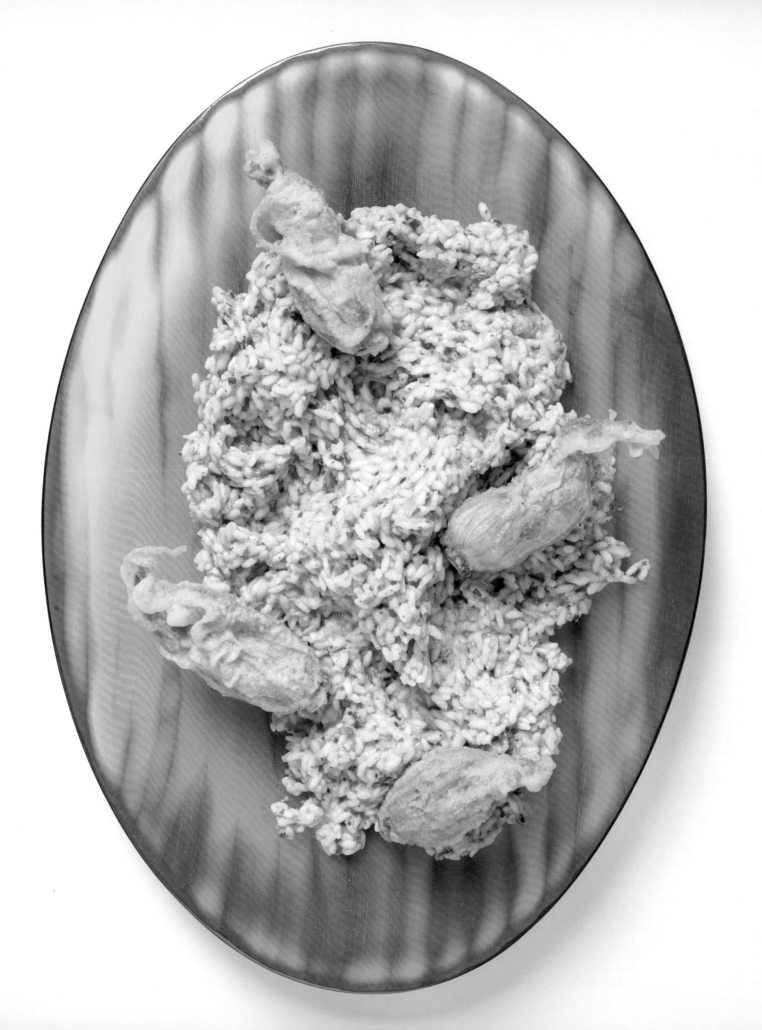

RISOTTO DI FEGATINI
(CHICKEN LIVER RISOTTO)

This is another very typical and very cheap dish to make, but where the main ingredient (chicken liver) needs to be of excellent quality. Until not so long ago it was customary to sell chickens with their giblets. This is now rather rare, and most people don't ask for the giblets even when they buy their chicken from a good butcher. The liver should be an intense red color, of firm consistency, and not oversized. If it looks any different, then it very probably comes from a chicken that has been badly fed or that has suffered in some other way. If possible use chicken stock to cook the risotto.

SAUTÉ
the onion in extra virgin olive oil on very low heat, lid on, until soft. As soon as the onion starts to brown, add the white wine and cook until it evaporates (the longer you cook the onions the better).

IN THE MEANWHILE
wash the chicken livers thoroughly and cut into small pieces. Make sure that all the bile has been carefully removed (the bile is green, so it's very easy to spot), otherwise the risotto will be very bitter.

ADD
200gr of livers to the onion.

THEN ADD
the rice, stir well, and toast for 2–3 minutes, or until it becomes slightly translucent.

LADLE
boiling stock to cover the rice and stir continuously to release the starch from the rice.

ADD
more stock, one ladle at a time, as the rice absorbs it, and stir continually.

COOK
for about 20 minutes, or until the rice is cooked through and the risotto has a creamy consistency (cooking times will vary depending on the type of rice you use).

REMOVE
from the hob, add the butter and Parmesan, and stir vigorously until you get a creamy consistency.

GARNISH
with freshly chopped parsley, and add the remaining livers that have been lightly fried. Season with sea salt and black pepper.

INGREDIENTS

320gr
Carnaroli rice

300gr
chicken livers

1.5lt
chicken stock

150ml
dry white wine

1
small onion, finely chopped

50gr
butter

100gr
Parmesan cheese

3 tbsp
parsley, finely chopped

4 tbsp
extra virgin olive oil

sea salt and black pepper, to taste

preparation time
40 minutes

serves 4

Baccellato plate
Murano production,
1920s

GNOCCHI DI PATATE AL POMODORO
(POTATO GNOCCHI WITH TOMATO SAUCE)

Making gnocchi is perfectly simple and only complicated by the fact that the choice (and availability) of the correct variety of potatoes will make all the difference. Old potatoes, naturally rich in starch, are the ones to go for. But these "old" potatoes are not always easy to find in countries where gnocchi are not as common a dish as in Italy. The older and richer in starch the potatoes are, the less flour you'll need to add—and this means you'll end up with a gorgeously soft, fluffy consistency. When you've finished cooking and mixing the mashed potatoes with the flour and egg, have a small pot of boiling water at the ready and dip in a couple of gnocchi to test them. If they fall apart you'll need to add more flour; if they stay together they are perfect. The following sauce recipe can also be used for pasta, and is absolutely delicious.

WASH

the potatoes thoroughly and put them in a large pot of cold salted water. Do not peel the potatoes as their skin will stop them from absorbing too much water.

BOIL

the potatoes until they are very soft (use a roasting fork to check). You're better off overcooking rather than undercooking your potatoes, as the rawer potatoes will make your gnocchi mixture lumpy.

PEEL

and mash the boiled potatoes very finely. Your best aid would be a fine Mouli grater. Never use a food processor as the natural starch in the potatoes will make them very elastic and completely unsuitable for gnocchi.

PLACE

the mashed potatoes in a bowl, add the egg yolks, a little salt, and some flour. Usually the mixture is ready when it no longer sticks to your fingers, but this rule of thumb doesn't always apply, so you'll need to test your gnocchi as you go.

HAVE

a pot of salted boiling water at the ready. Use a little of the dough mixture to make two gnocchi, which you will use to test the consistency. When you plunge the gnocchi into boiling water they should go to the bottom of the pot and then resurface after a couple of minutes. As soon as they do, remove them from the water with a slotted spoon and taste. If they don't fall apart and have a pleasantly firm consistency, then they're just right.

ROLL

the mixture into snake-like logs about 2cm thick, and cut the logs into segments about 3cm long.

INGREDIENTS

for the gnocchi

1kg
old potatoes

200gr
flour, approximately

2
egg yolks

sea salt, to taste

for the sauce

1kg
ripe cherry tomatoes

4 tbsp
extra virgin olive oil,
plus 2 extra tbsp to finish

2
cloves of garlic

sea salt and pepper,
to taste

20 leaves
fresh basil

freshly grated Parmesan cheese,
to taste

preparation time
1h 30 minutes

serves 4

ROLL

each piece (gnocco) over the back of a fork to give them a nice appearance, and place them on a well-floured surface.

PUT

the washed tomatoes into a pan with the extra virgin olive oil, the whole garlic cloves, and a little salt.

COVER

with a lid and cook the tomatoes over a low heat until they burst and release their water.

USE

a wooden spoon to mash the tomatoes into a smooth sauce. Put back on the hob uncovered and cook until most of the liquid has evaporated and the sauce has thickened. The time required for this will vary depending on how much water the tomatoes release. The plumper the tomatoes are, the less water they will release.

ONCE COOKED

add the basil, 2 tbsp of extra virgin olive oil, and season with salt and pepper to taste.

COOK

the gnocchi in boiling salted water, remove them from the pot with a slotted spoon, and place on a flat serving dish.

ADD

the sauce and mix very gently to avoid breaking the gnocchi.

DUST

with Parmesan cheese to taste.

following pages
Canoa
Tobia Scarpa and Ludovico Diaz
de Santillana for Venini, 1960

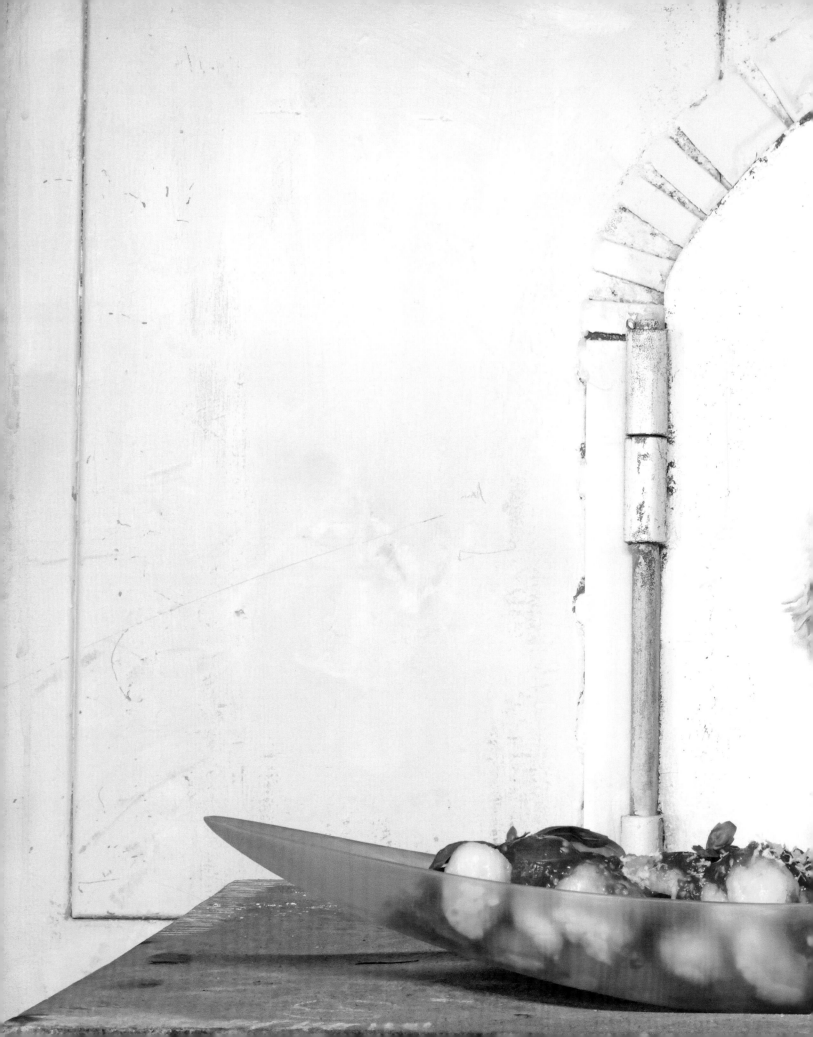

PASTA E FAGIOLI
(BEAN AND PASTA SOUP)

When the season of fresh borlotti beans arrives, it's time for pasta e fagioli! Shelling fresh beans is therapeutic, and cooking them with just the right ingredients a real joy. Fresh beans are very different from the canned ones, which tend to taste more of preservatives than beans. Take some time to make your own stock, too, as this will make a huge difference and taste much better than stock made with a stock cube or ready-made, store-bought stock.

IN A POT

on medium heat, add the extra virgin olive oil and, when hot, add the bacon or pancetta and the rosemary and cook for a couple of minutes until the bacon releases its own fat.

ADD

the onions, carrots, and celery (also called the *soffritto*) and cook on a very low heat for at least 15 minutes, adding a little water if it starts coloring.

WHEN

the vegetables are tender add the beans.

ADD

the stock, and cook for 1 hour (fresh beans take about 40 minutes to cook).

REMOVE

half the beans from the pot, using a slotted spoon, and set aside.

PLACE

the rest of the beans along with the liquid in the food processor and pulse until you have a creamy mixture. You can also use a handheld blender if you prefer, which is easier.

PLACE

the creamed bean soup and whole beans back in the pot, add a large glass of stock or water, and bring back to the boil. Season with salt.

ADD

the pasta and cook until the pasta is *al dente*. You'll need to stir the soup frequently to stop the pasta from sticking to the bottom of the pan. If the soup gets too thick, gradually add a little water or stock until the pasta is cooked.

SERVE

in soup dishes or bowls, with a drizzle of extra virgin olive oil and a dusting of Parmesan cheese and freshly grated black pepper to taste. The soup should be quite thick, and should never be served piping hot. Be warned—it will taste even better the day after!

INGREDIENTS

1kg
fresh beans in their pods
(or 300gr dried borlotti beans, soaked overnight)

1
large carrot (or 2 small carrots), peeled and very finely chopped

1
large onion, finely chopped

2
celery stalks, finely chopped

100gr
smoked bacon or pancetta, in small cubes (optional)

1
large sprig fresh rosemary leaves, finely chopped

beef stock, freshly made or from stock cube

200gr
small pasta (tubetti or pennette)

freshly ground black pepper, to taste

4 tbsp
extra virgin olive oil

100gr
freshly grated Parmesan cheese (optional)

preparation time
2h + soaking time

serves 4

Small *Pirus* bowls
Carlo Moretti, 2001

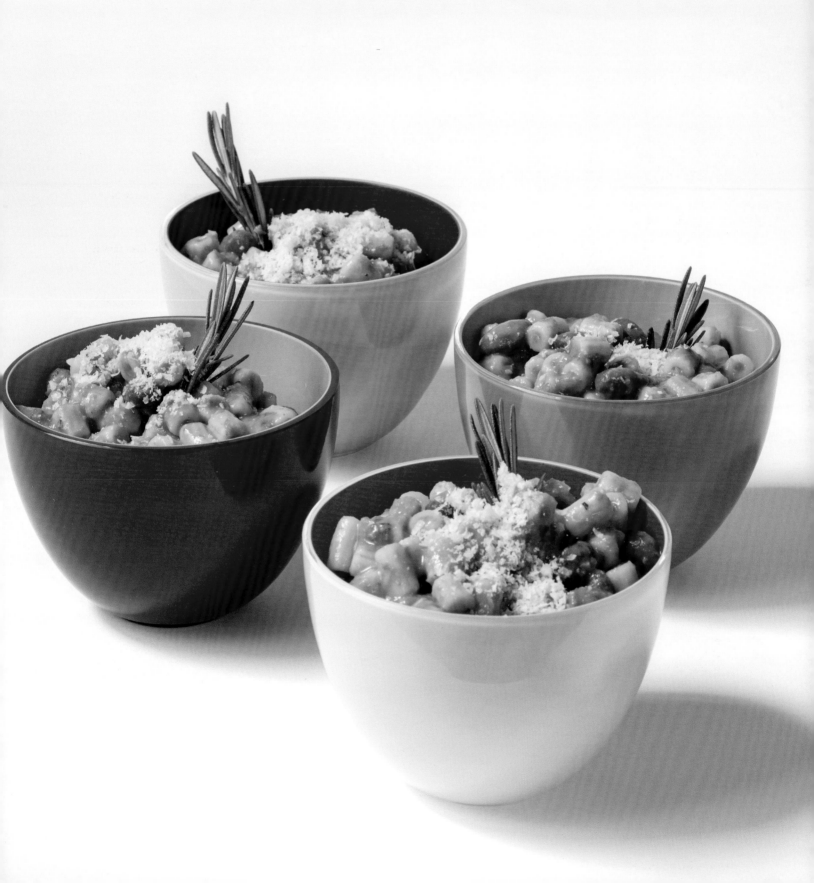

ZUPPA DI PESCE CON ZAFFERANO
(FISH SOUP WITH SAFFRON)

Good fish is very expensive, so you always want to try and use everything you buy and make it go a long way. A good fish soup is an excellent example of a dish where you will use the fish's bones, heads, and offcuts to create a really tasty stock.

Saffron is the most expensive ingredient in the world, but not all the saffron sold as such is the real thing. Be very careful as you will often be offered alternative ingredients, most often turmeric powder, which will add color but not the distinctive flavor of saffron.

The best saffron in the world comes from Iran, Spain, and Italy (specifically from the Marches and Sardinia). Saffron pistils are usually more flavorsome than saffron powder. These need to be regenerated in a little hot water or stock for about an hour before you use both the pistils and the water they've been soaking in.

POUR

the extra virgin olive oil into a large stock pot and heat. When hot, add all the fish bones, prawn heads, and all the other ingredients except for the tomatoe.

COOK

for at least 20 minutes to allow the bones to seal properly and the vegetables to release their flavor to the max.

ADD

the tomatoes and cook for a further 5 minutes.

FILL

the stock pot with water and the white wine. Bring gently to the boil and simmer for at least one and a half hours. While the stock is simmering away, you can prepare the rest of the ingredients.

PLACE

the saffron pistils in a bowl, cover them with a small ladle of hot stock, and set aside.

PEEL

the prawns, throw the shell into the stock pot (in Italian we say that *tutto fa brodo*—anything can be used to make a stock), and set aside the flesh.

REMOVE

the flesh from the scallops and set aside (don't throw the shells into the stock—they would add no flavor at all).

CLEAN

the calamari and cut them into 2 or 3 pieces depending on the size—if you've got large ones, then cut them into bite-size rings.

INGREDIENTS

for the stock

50ml
extra virgin olive oil

1kg
rockfish, or fish bones
and heads

the heads of 12 prawns

1
large carrot, roughly diced

1
large onion, roughly sliced

1
stick of celery, roughly sliced

1
bay leaf

a few stalks of fresh parsley

1
tomato, cut in half

20
peppercorns, whole

500ml
dry white wine

sea salt and black pepper,
to taste

following pages
Bowl
Ritsue Mishima, 2013

CUT

the fish fillets into bite-size pieces (you can leave them a little bigger for presentation purposes if you wish).

OPEN

the mussels in a pan with a little extra virgin olive oil (see page 52). If they don't open, throw them out, as it means they are dead and could cause food poisoning.

REMOVE

the mussels from the pan and add the liquid they released to the stock.

REMOVE

one side of the shell from the mussels and set aside.

TOAST

the ciabatta bread and gently rub with garlic. Place in a breadbasket.

ONCE

the stock is ready, filter it through a chinois or sieve into another pot.

PLACE

all the bones and vegetables in a Mouli grater and squeeze out as much as you can of the bones and vegetables into the stock.

BRING

the stock back to the boil, add the saffron together with its soaking liquid, and reduce to about the amount that would fill 4 soup dishes. Season to taste. Add a little chopped chili for extra "bite".

ADD

all the fish and seafood to the stock except for the mussels as they are already cooked.

COOK

for no longer than 5 minutes. Remove from the hob and add the mussels (they will warm up in no time).

PLACE

the soup in a relatively shallow bowl and garnish with freshly chopped parsley.

for the soup

600gr
white fish fillets (I would recommend monk fish for its robust consistency)

16
fresh mussels

12
large prawns (the heads go into the stock)

8
baby calamari, or squid

4–8
scallops

1
red chili pepper, chopped (optional)

1
small bunch parsley, freshly chopped

2 tbsp extra virgin olive oil

saffron pistils

sea salt and black pepper, to taste

for the crostini

8
slices ciabatta bread

2–3
cloves of garlic

preparation time
2h

serves 4

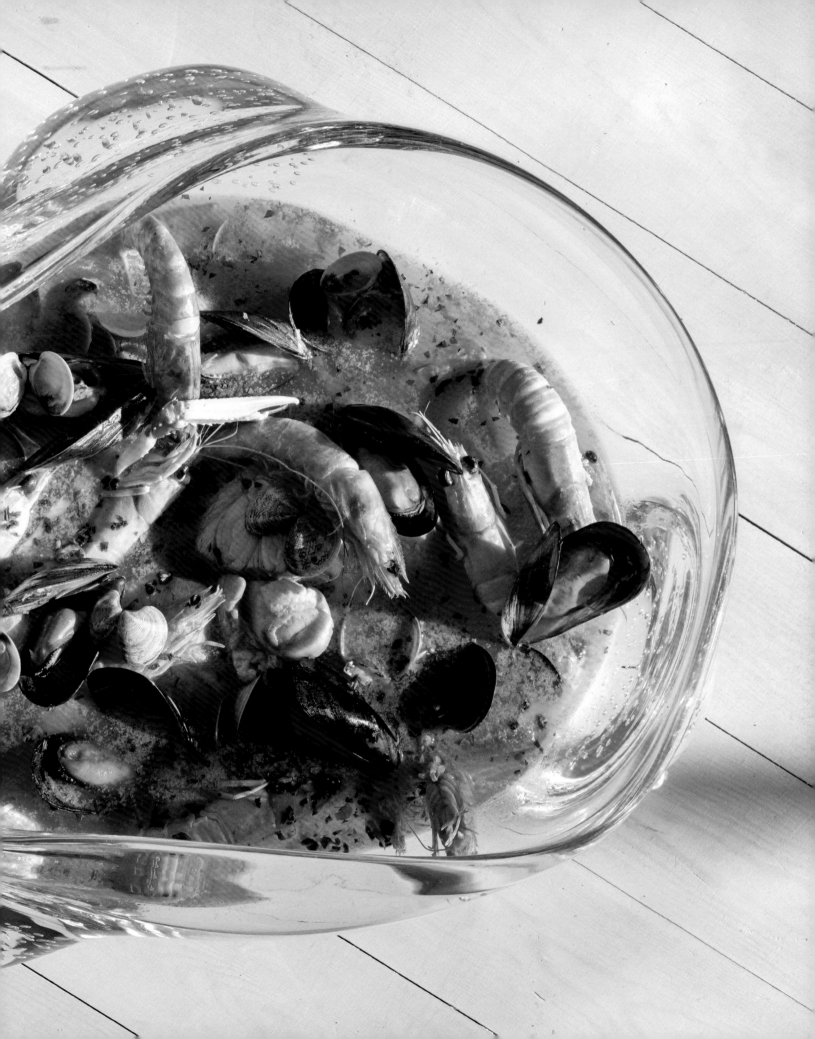

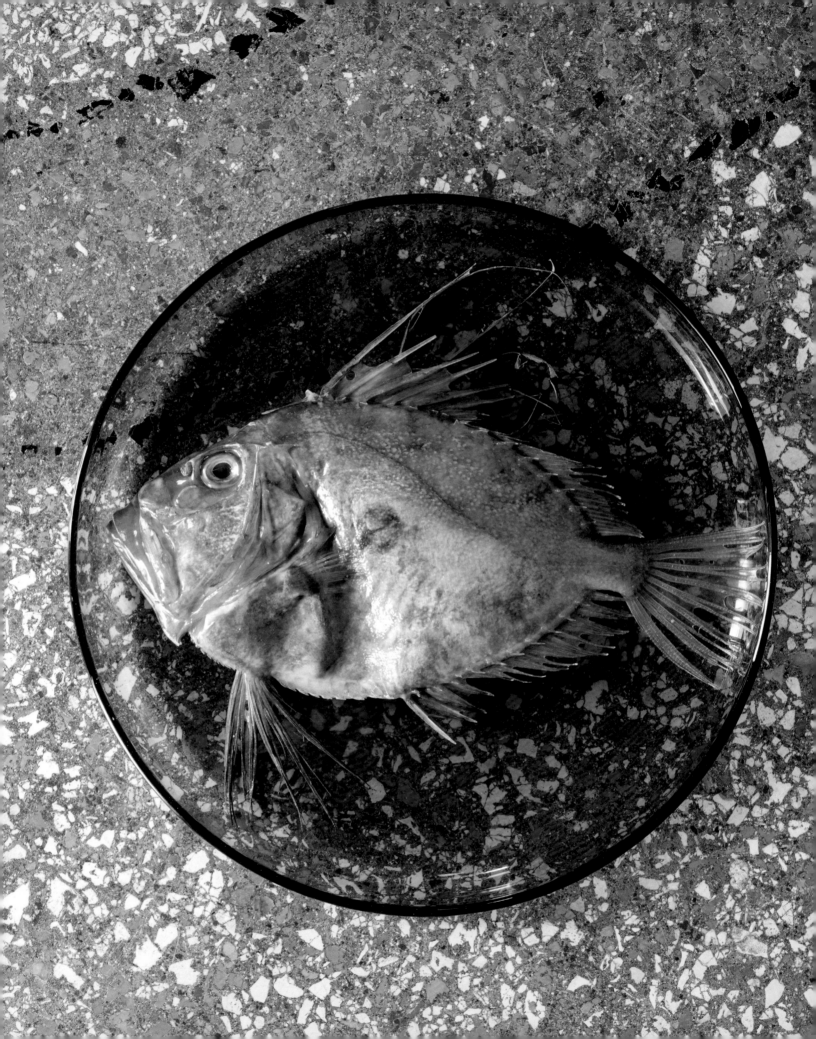

MAIN COURSES

FRITTO MISTO CON VERDURE
(ASSORTMENT OF FRIED FISH OR MEAT WITH VEGETABLES)

Everybody loves a Venetian *fritto misto*, but most restaurants (if not all of them) only serve the *fritto misto di pesce* (fish and seafood). There are, in fact, two kinds of *fritto misto*, but one of them is no longer offered as very few people would now order it.

So what exactly is in this other *fritto misto*? Well, it is composed of fried vegetables and crispy brains or sweetbreads. After the mad cow disease scare, when the sale of both brains and sweetbreads was prohibited, this amazing dish never quite made a comeback. So, if you want to try it, just replace all the fish and seafood with equal amounts of brains and sweetbreads.

FOR THE BATTER,
place 100gr of flour, beer, and salt in a bowl and mix thoroughly until you obtain a smooth consistency. Cover with cling film and let rest in the fridge for about 30 minutes. You will only need the batter for the vegetables.

WASH
and thoroughly pat dry all the seafood. Dust all the fish and the seafood with a little flour, shaking off any excess.

CUT
all your vegetables.

TAKE
the batter out of the fridge, whisk egg whites until stiff, if you are using them, and incorporate.

HEAT
the oil to 170°C in a pan or wok.

DIP
the vegetables in the batter and deep fry until golden brown. Do not fry too many items at a time as this will cause the temperature of the oil to drop and you'll end up with very greasy vegetables.

ONCE FRIED
place the vegetables on paper towels to remove any excess oil.

ONCE
all the vegetables are fried, repeat with the fish and seafood.

PLACE
all your *fritto misto* on a serving dish with a few paper towels and sprinkle generously with sea salt flakes. Add a few lemon wedges.

SERVE
with a salad.

INGREDIENTS

1 large pepper

2 carrots, cut into 5cm sticks

2 zucchini, cut into 5cm sticks

1 eggplant, white part removed, cut into 5cm sticks

8 champignon mushrooms, cut in half

300gr mixed shellfish such as scallops and mussels, shells removed

4 sardines, heads removed

4 baby red mullets, gutted and scaled

2 large calamari, cleaned and cut into 2cm rings

8 prawns, tails peeled (or 100gr baby calamari tubes)

2 lemons

150gr flour

2 egg whites (optional)

200ml beer

sea salt, to taste

1l frying oil (quantity varies according to the size of the pan)

preparation time
1h 30 minutes

serves 4

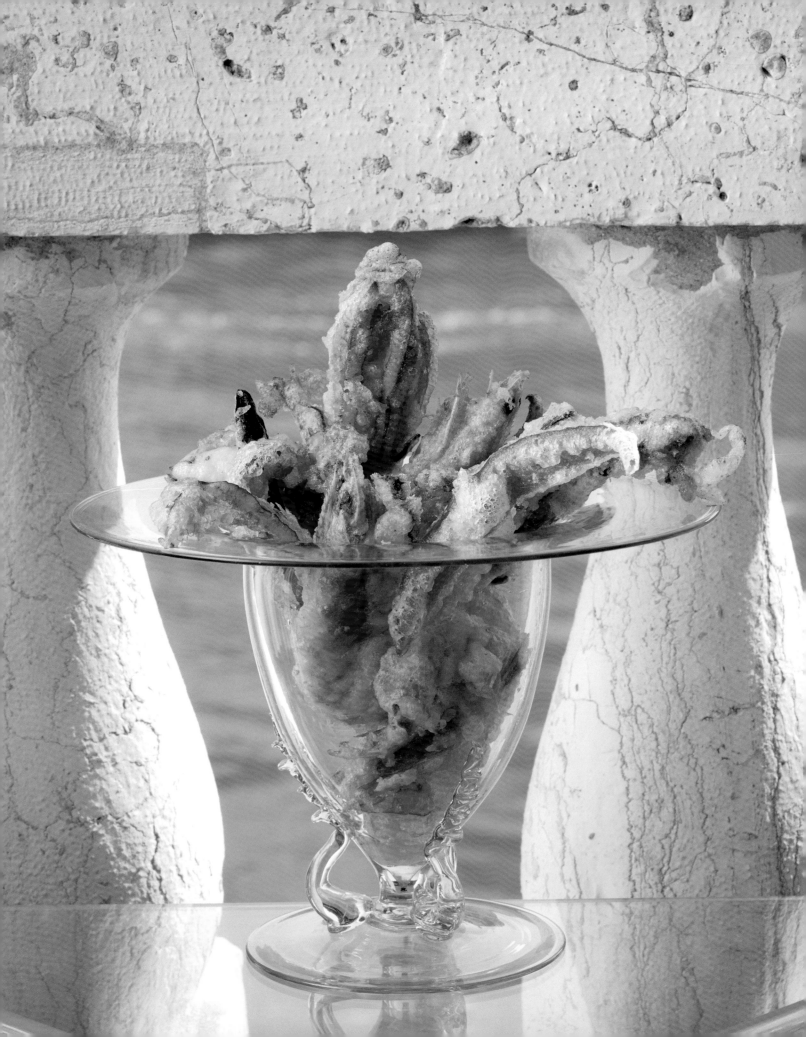

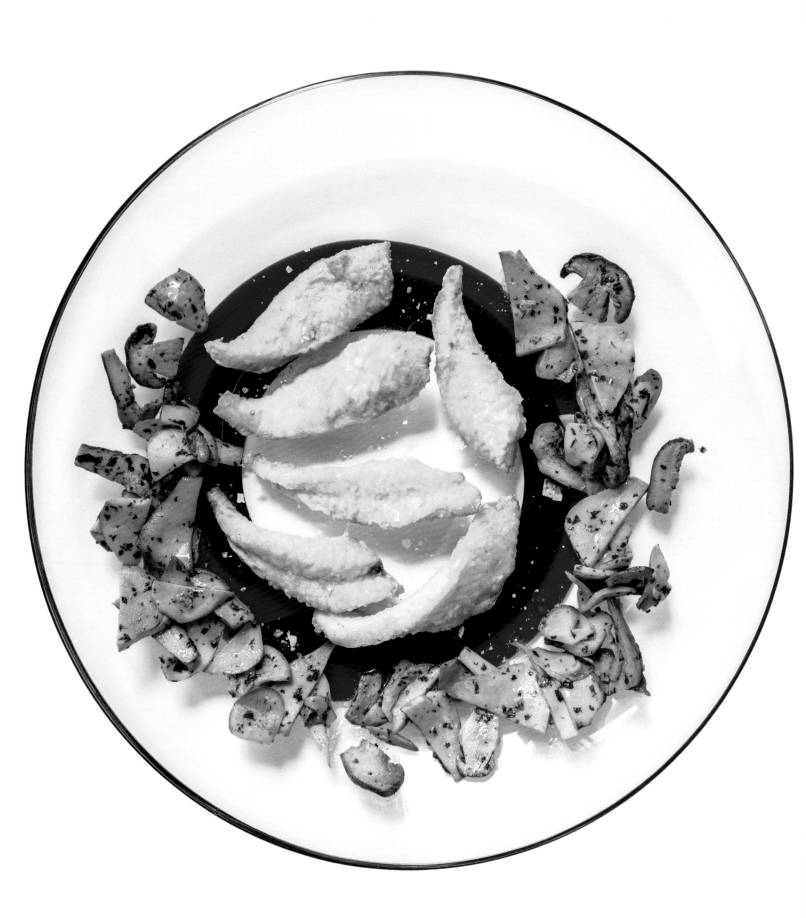

FILETTI DI SAN PIETRO CON FUNGHI

(JOHN DORY FILLETS WITH PORCINI MUSHROOMS)

San Pietro (known as John Dory, St. Pierre, or Peter's fish in English) is an amazing fish whose delicate flavor should never be ruined by adding too many overpowering ingredients. According to popular Venetian lore, the fish is given the name of St Peter because the two black spots on either side of the fish are believed to be the prints of Saint Peter's thumb and index finger left on the fish the day he picked it up to give to Jesus.

An alternative to this recipe would be to replace porcini with artichokes. Artichokes are a specialty of the Venetian islands, and added to the John Dory they give us a perfect example of two local products that blend to perfection, each respecting and enhancing the other. If you cannot find any mushrooms or baby artichokes, you can use thinly sliced zucchini, which work brilliantly because of their subtle flavor.

CLEAN

the mushrooms and thinly slice them.

SEASON

the fish fillets with salt and pepper and lightly flour.

IN A PAN

heat 50ml of the extra virgin olive oil and 50gr of the butter and, when sizzling, add the fish fillets. Cook until golden brown on both sides, but do not overcook (no more than 3 minutes per side).

ONCE

cooked, remove from the pan and place on a dish. Keep warm.

CLEAN

the pan and add the 30ml of extra virgin olive oil and 30gr of butter, and heat until sizzling.

ADD

the mushrooms and sauté for a few minutes, or until tender.

SEASON

with salt and pepper to taste and garnish with a sprinkling of freshly chopped parsley.

CREATE

a bed of mushrooms on the bottom of a serving dish and top with the fish fillets.

INGREDIENTS

600gr
John Dory fillets

plain white flour
(enough to lightly coat
the fillets)

salt and pepper, to taste

80ml
extra virgin olive oil

80gr
butter

8
small porcini mushrooms
(do not use dried porcini as their
flavor is too strong and would
overpower the fish)

1 tbsp
parsley, freshly chopped

salt and pepper, to taste

preparation time
30 minutes

serves 4

Plate from
the *Fasce nero e rosso* series
Carlo Moretti, 1989

previous pages
Bowl
Vittorio Zecchin
for MVM Cappellin, 1920

PESCE AL FORNO CON PATATE
(BAKED FISH AND POTATOES)

Every sea has its own fish, so it is difficult to give a complete list of the different types of fish you can use for this dish. Choose a white fish which weighs at least 1kg—anything less would just quickly dry out in the oven. I use whatever herbs I have at home, but I'd advise you to avoid dill and mint as they are too strong. I also use different garnishes depending on my mood. In the fall I love using fresh porcini mushrooms—a combination we call *mare e monti* (sea and mountains). If I serve pasta as a starter, then I eliminate the potatoes and just use tomatoes, spring onions, and olives. If you are using a flat fish such as a turbot, the cooking times may vary.

PREHEAT
oven to 200°C.

CLEAN
the whole fish, making sure to remove the innards and gills (you can probably get your fishmonger do this for you).

SEASON
the inside of the fish with salt and pepper, and add sprigs of fresh herbs (squeeze and twist the herbs so they release their essential oils and fragrances).

PLACE
the fish in an oven proof dish.

SLICE
the potatoes very thinly and place them in a bowl with the halved tomatoes, and olives.

TOSS
with salt pepper and olive oil.

PLACE
the vegetable mixture in a wreath around the fish (do not place vegetables underneath the fish as they will not cook).

POUR
white wine over the vegetables.

PLACE
in oven and bake for 30–40 minutes.

INGREDIENTS

1.5kg
sea bass, sea bream,
or any white fish

fresh herbs such as rosemary,
thyme, and sage

20
cherry tomatoes, halved

600gr
red potatoes

20
taggiasca olives

3 tbsp
extra virgin olive oil

65ml
white wine

sea salt and black pepper,
to taste

preparation time
1h

serves 4

Plate
Massimo Micheluzzi, 2013

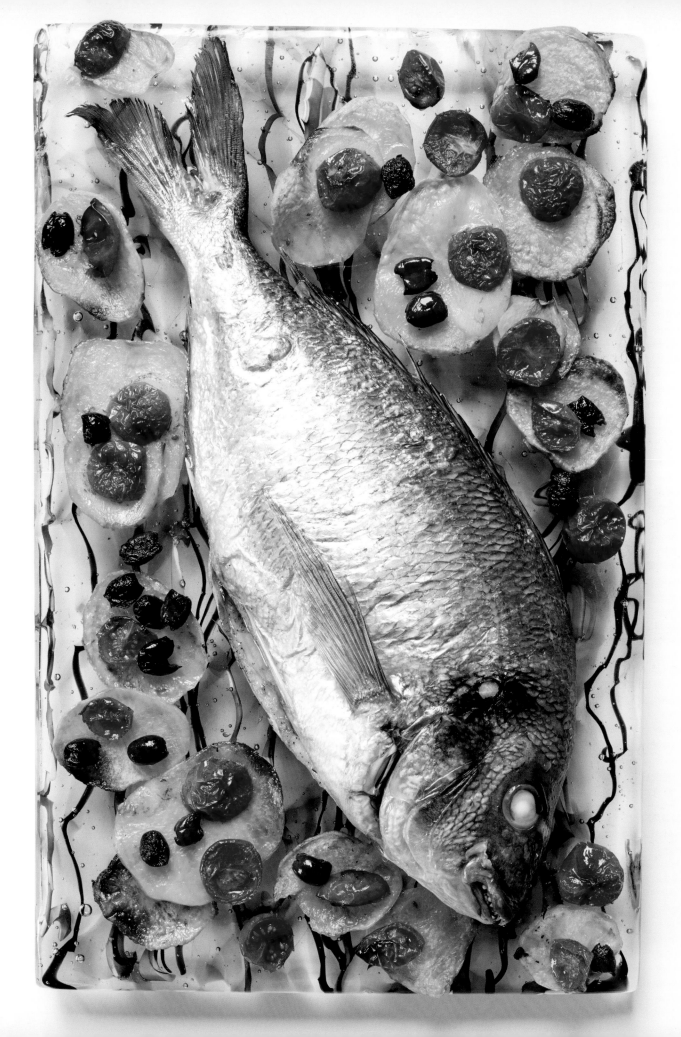

INSALATA DI FAGIOLI UOVA E TONNO
(BEAN, EGG, AND TUNA SALAD)

On a warm summer's day, this is a perfect light, complete lunch.
I hate to say this, but if you're really in a rush you can use canned Borlotti beans. Rinse them thoroughly to get rid of all the preservatives as well as the can flavors, and then proceed as per the recipe.
The type of canned tuna you use is very important—tuna fillets, though much more expensive than normal canned tuna, have a much firmer and more pleasant consistency. They also look much better, which certainly helps.

SHELL
the fresh beans, or soak the dried beans in water overnight (the amount of water should be three times the volume of the beans).

FILL
pot with water and add the halved onion, rosemary sprig, olive oil, fresh or soaked beans, and salt.

BRING
to the boil and cook at medium–brisk boil for about 40 minutes , or until the beans are nice and soft (dried beans usually take a bit longer to cook than fresh beans, so 1 hour for dried beans).

STRAIN
the beans and place in a bowl.

ADD
the finely sliced red onion, tuna, chopped parsley, olive oil, and salt and pepper to the bowl of beans.

TOSS
carefully until the tuna is evenly distributed.

PUT
in a serving dish and lay quartered hardboiled eggs on top.

GARNISH
with chopped parsley.

INGREDIENTS

200gr
dried borlotti beans, soaked overnight (or 1kg fresh beans in their pods)

1
onion, halved

1
sprig rosemary

4 tbsp
extra virgin olive oil

sea salt, to taste

for the salad

1
medium red onion, finely sliced

300gr
canned tuna filets

2
eggs, hardboiled for 10 minutes and cut into quarters

4 tbsp
extra virgin olive oil

sea salt and black pepper, to taste

parsley for garnish

preparation time
1h + soaking time

serves 4

Loto bowl
Salviati, 1980s

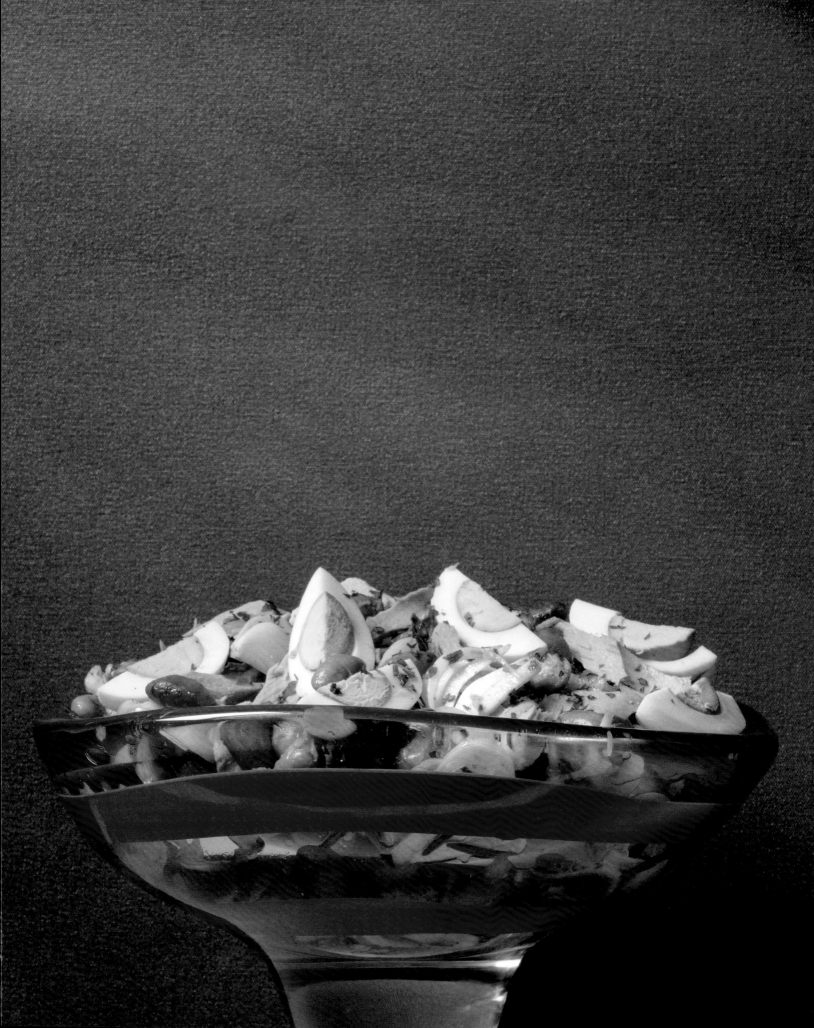

CARPACCIO

Carpaccio was created in Venice in the 1950s by Giuseppe Cipriani (founder of the famous Harry's Bar) for an Italian contessa who could not eat cooked meat and was tired of tartare. The dish was named after an Italian painter, Vittore Carpaccio, who was famous for his love of deep reds. The main ingredient is beef sirloin, fat removed, and very thinly sliced. The dressing is a Jackson Pollock-spray of light mayonnaise mixed with lemon juice, mustard, and Worcestershire sauce. There is also a Piedmontese version which, with the same ingredient (raw beef), is dressed very simply with olive oil, lemon juice, rocket leaves, and flakes of Parmesan cheese. Either way, it is important to roll the meat in cling film to keep its shape and freeze it as it is otherwise impossible to slice it paper thin. Take the meat out of the freezer 1 hour before slicing it. The only way to cut it very thinly is by using a meat slicer, so if you don't have one, freeze your meat and then take it to your butcher and ask him to slice it for you.

Venetian version

PUT
egg yolk, mustard, and a little salt and pepper into a medium mixing bowl and whisk until thoroughly blended.

ADD
60ml of the oil drop by drop, whisking constantly as you would if you were making mayonnaise. Gradually add the rest of the oil in a thin, steady stream, continuing to whisk as the mixture thickens.

ADD
the lemon juice, to taste, and adjust the seasoning. If the mixture seems to be too thick, whisk in a little milk to thin it out.

PUT
125ml of the mayonnaise into a small mixing bowl (you can keep the rest for future use); whisk in Worcestershire sauce and 1 tbsp of lemon juice, and enough milk to make a thin sauce that just coats the back of a wooden spoon. Season to taste with salt and pepper and add a little more Worcestershire sauce or lemon juice if you like.

MAKING SURE
the beef is still very cold, slice it as thinly as possible with the help of an electric meat slicer.

INGREDIENTS

400gr
beef fillet or sirloin, external fat removed and froze

Venetian version

1
egg yolk

1 ½ tsp
dry mustard powder or French mustard

sea salt and white pepper

180ml
vegetable oil

juice of ½ lemon

2 tsp
Worcestershire sauce

3 tbsp
milk

Piedmontese version

100gr
rocket leaves

juice of 1 lemon

30ml
extra virgin olive oil

50gr
Parmesan cheese, shaved into flakes

preparation time
30min + resting time

serves 4

ARRANGE

the sliced meat on 4 chilled plates, forming one thin layer, to completely cover the surface of the plates. Drizzle some of the sauce over the meat on each plate and marinate for 2–3 minutes.

Piedmontese version

MAKING SURE

the beef is still very cold, slice it as thinly as possible with the help of an electric meat slicer.

ARRANGE

the slicead meat on 4 chilled plates, forming one thin layer, to completely cover the surface of the plates.

ADD

a little lemon juice (but only just before serving, as otherwise the acidity of the lemon will cook the meat).

DRIZZLE

with a little extra virgin olive oil and season with salt and pepper.

DECORATE

with rocket leaves and flakes of Parmesan cheese.

following pages
Flat plate
Massimo Micheluzzi, 2013

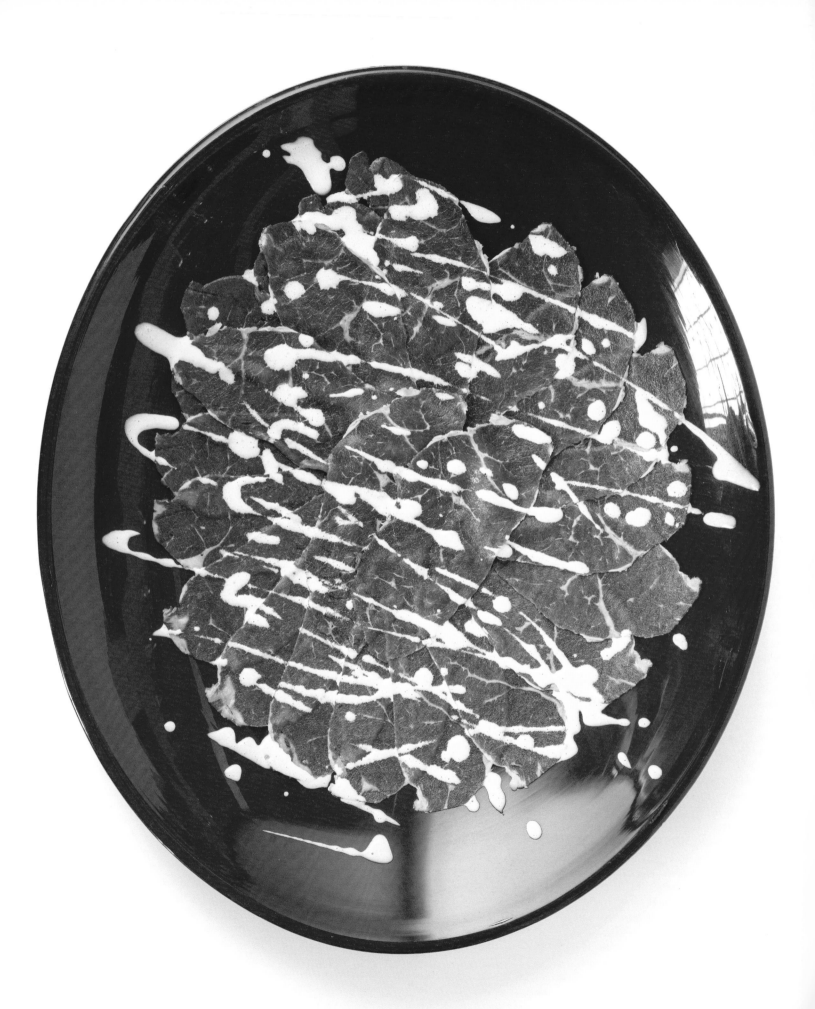

POLENTA E OSEI
(ROASTED QUAIL AND POLENTA)

Originally this recipe made use of very small, bite-size birds such as larks and thrushes, but as it is now totally illegal to sell these, quails are a perfect alternative. Because of the very small size of the original birds, one needed at least 6 to 8 per person, and they were cooked and served on skewers. With quails, 2 per person is sufficient.
The lard or pancetta will keep the birds moist as they are very lean, and without it the meat would dry out very fast.

SEASON
the quails with salt and pepper.

WRAP
each quail with a slice of lard or pancetta (unsmoked as you do not want to alter the taste of the meat).

HEAT
the oil in a frying pan and when hot sear the birds on all sides.

LOWER
the heat, add the sage leaves and fry for a minute.

ADD
the white wine and chicken stock and cover with a lid.

COOK
for 20 minutes and if there is still too much liquid, remove the quails, set them aside, and reduce the sauce until it's nice and thick.

SERVE
with grilled or soft polenta.

INGREDIENTS

8
whole quails

8
slices lard (Colonnata lard is the best) or pancetta

4 tbsp
extra virgin olive oil

16
sage leaves

250ml
dry white wine

250ml
chicken stock

sea salt and black pepper, to taste

preparation time
30 minutes

serves 4

Tweens
Massimo Nordio, 1998

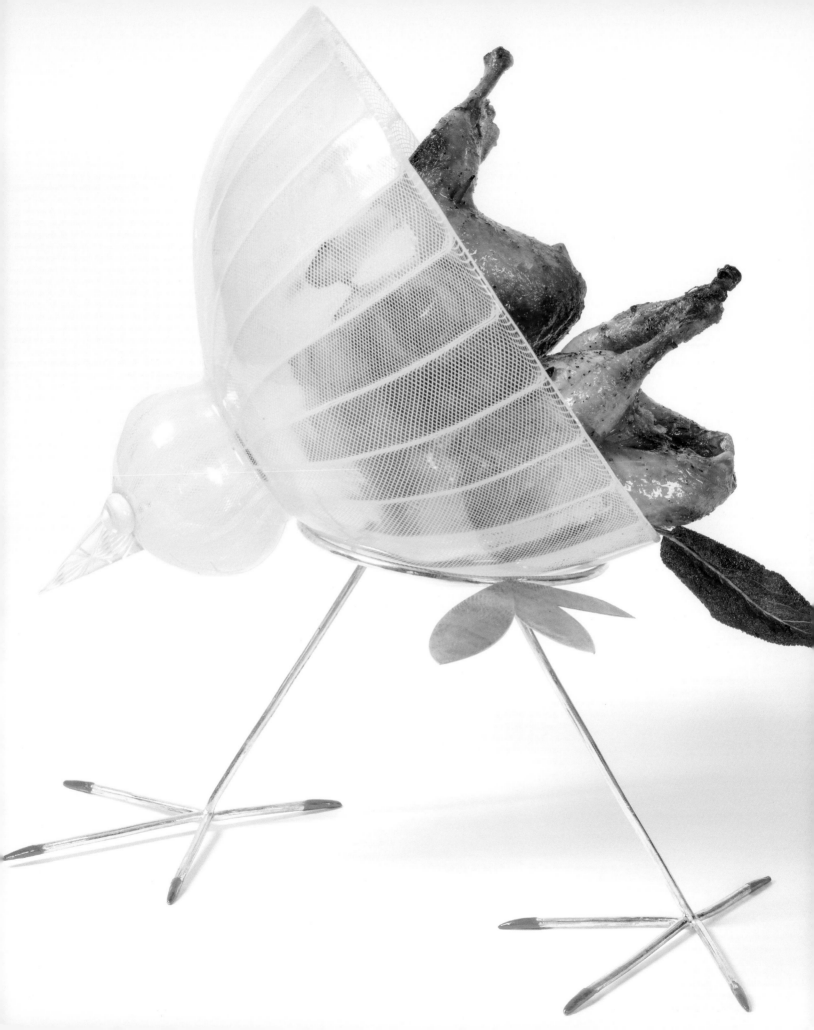

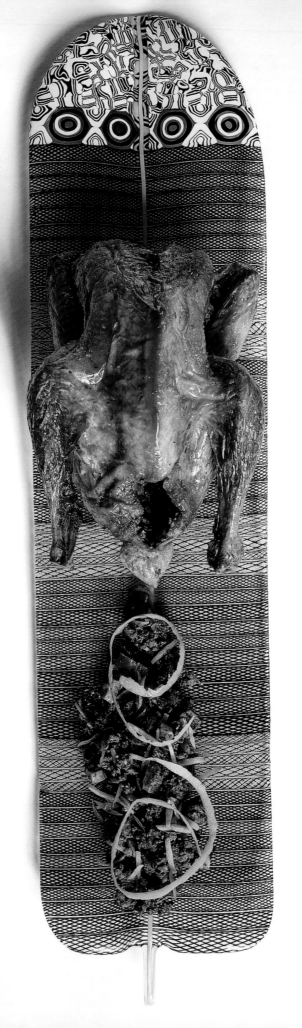

FARAONA CON SALSA PEVARADA
(GUINEA FOWL WITH PEVARADA SAUCE)

Eating chicken today is becoming almost dangerous because most is badly fed, battery produced fodder. Guinea fowl is therefore a much better option—it's much less in demand (and therefore isn't being battery produced), and if you're lucky you might find a wild one. In Venice, you'll find wild Guinea fowl from the Po' estuary, and these are, quite simply, amazing. Make sure you also get the giblets, as you'll need them for the *pevarada* sauce. This recipe can also be made using rabbit. As rabbit is a very lean meat, I suggest you wrap it in thin slices of lard or pancetta to stop it from becoming too dry.

PREHEAT
 oven to 200°C.

RUB
 the freshly chopped herbs and garlic on the inside of the bird. Season with salt and pepper. Place in an oven proof dish with thick cubes of pancetta and the white wine, and roast for one hour.

CHOP
 the raw liver and add it to a pan with the chopped garlic, lemon zest, lemon juice, anchovies, parsley, salt, and a generous helping of pepper.

SAUTÉ
 all the ingredients over a medium–low heat for 8–10 minutes, or until the liver is cooked through and becomes fragrant.

PORTION
 the Guinea fowl and place on a serving dish.

DRIZZLE
 the roasted Guinea fowl with the *pevarada* sauce and garnish with lemon zest and freshly chopped parsley.

INGREDIENTS

1
whole Guinea fowl

2 tbsp
freshly chopped sage
and rosemary

1
whole garlic clove

50gr
pancetta cubes

125ml
white wine

salt and pepper, to taste

peverada sauce

100gr
Guinea fowl liver (chicken liver
is a valid alternative)

6
anchovy filets

1 tbsp
chopped parsley

2
cloves garlic, chopped

juice of 1½ lemons

zest of ½ a lemon

sea salt and black pepper,
to taste

preparation time
1h 30 minutes

serves 4

Feather
Massimo Nordio, 2004

CONIGLIO
CON CARCIOFI
(RABBIT WITH ARTICHOKES)

Rabbit is a very popular meat in most of Europe. As it is an almost completely fat-free meat, it cannot be subjected to lengthy cooking (about 45 minutes is as far as you should go). If you plan to roast the rabbit, I suggest you roll it in thin slices of lard (Colonnata lard is the best) or pancetta to "feed" the meat and keep it wonderfully moist.

CLEAN

the baby artichokes. Remove the first 2 or 3 layers of tough leaves ans peel the stems. Cut the first 2cm from the top and quarter them. Place in a bowl of water with the piece of lemon to keep them from turning brown, and set aside.

SEASON

the rabbit with salt and pepper on both sides, then pan sear in olive oil until golden brown.

ADD

the white wine and evaporate.

ADD

the lemon juice, artichokes, and stock (if you don't have any stock, water will do as the bone marrow will add flavor).

KEEP

covered until the sauce reduces, but be careful not to overcook the rabbit.

IF

the rabbit is cooked but the sauce is still too liquid, remove the rabbit, reduce the sauce, and then return the rabbit to the sauce for a quick 1-minute reheat.

TOP

each serving with the pan juices and garnish with freshly chopped parsley.

INGREDIENTS

1
rabbit (about 2 or 2.5kg), cut into pieces

10
fresh baby purple artichoke hearts

¼ of 1 lemon

250ml
white wine

250ml
stock (optional)

extra virgin olive oil

juice of ½ lemon

salt and pepper, to taste

parsley, freshly chopped (for garnish)

preparation time
45 minutes

serves 6

Oval plate from the *Tinta* series
Lino Tagliapietra
for Effetre International, 1988

following pages
Small stand
Barovier & Toso, 1930s

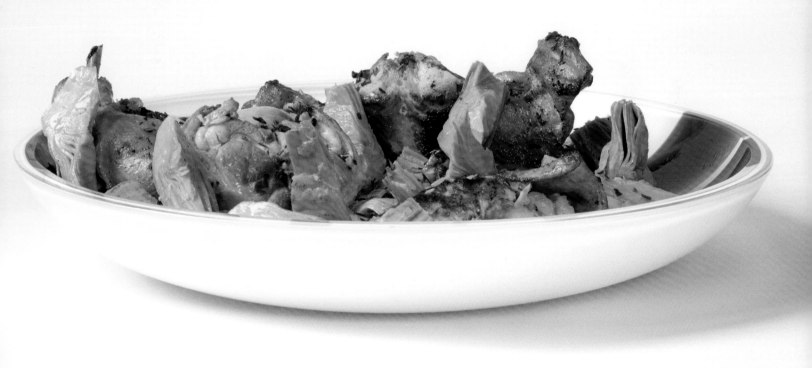

POLPETTE AL SUGO
(MEATBALLS WITH TOMATO SAUCE)

Ground or minced meat is one of the most creative ingredients to work with and I love concocting dishes with this very misunderstood and underappreciated product. Mince should always be a mix of beef and pork, and it greatly benefits from the addition of either a good pure pork sausage or 20% of mortadella ground with the meat. If you have any leftover cold meats in the fridge, grind them and add them to the mix. The more the better…

Traditionally we add a little white crustless bread soaked in a small amount of milk (always squeeze out any excess milk), but I prefer to add a little Ricotta or ground sweetbread as it gives an amazingly soft texture and extra, very subtle flavor.

MIX
the ground meats together in a bowl and season with salt and pepper.

ADD
the parsley, garlic, eggs, and nutmeg.

GIVE
extra texture and flavor to the mixture by adding the Ricotta, or the milk-soaked rustic bread (soak the bread, crust removed, in milk; squeeze out any excess liquid, then grind), or the sweetbread or brains (ask your butcher to remove the skin-like membrane before grinding if you prefer).

USE
your hands to mix all the ingredients and put aside for 4–5 hours (or even overnight if you can), allowing the meat to absorb all the flavors.

ROLL
small amounts of the mixture into meatballs, then flatten to a diameter of about 4cm before lightly flouring.

HEAT
the extra virgin olive oil and butter in a frying pan on high heat. When nice and hot, add the meatballs and fry until they form a golden brown crust on each side (about 2–3 minutes).

ADD
a high quality tomato passata and cook for about 20–25 minutes on low heat.

AN ALTERNATIVE
would be to sear the lightly floured meatballs, then add freshly chopped herbs such as rosemary and sage, 125ml of white wine and 125ml of water or stock. Cook for about 20–25 minutes on low heat, until the sauce thickens.

INGREDIENTS

250gr
ground beef

250gr
ground pork

100gr
**ground mortadella,
or pure pork Italian sausage**

40gr
parsley, chopped

2
cloves of garlic, finely chopped

2
medium eggs

¼ tsp
nutmeg

2–3
pinches of salt

**freshly ground black pepper,
to taste**

200gr
**Ricotta cheese
(or 200gr milk-soaked rustic
bread, crust removed,
or 200gr ground sweetbread
or brain)**

750ml
tomato passata

25ml
extra virgin olive oil

25gr
butter

preparation time
1h

serves 4

MAIALE IN TECIA
(PORK IN A POT)

This is an incredibly tasty dish, and the quality of the pork is essential. This was brought home to me when I made this dish in Tokyo as part of a presentation. Because of the love and care Japanese farmers take in breeding their animals, they've created a quality pork that is difficult to find anywhere else in the world—and thanks to which I rediscovered the amazing flavors of the pork of my childhood.

Another incredibly good quality pork is fresh Spanish black pig, even though this is rather difficult to find. But, as only the legs are used for the hams, the rest of the meat can sometimes be found in very specialized butchers and is considered a real delicacy.

SEASON

the ribs and shanks with salt and pepper.

HEAT

oil in a pan on medium–high heat. Brown the pork on all sides until golden brown.

ADD

the finely chopped sage, rosemary, and garlic to the seared meat and stir for 1 minute to distribute the seasonings evenly and to allow the herbs to slightly brown and release their flavors (be careful not to burn the garlic).

ADD

the white wine and stock or water.

ARRANGE

the pork in a single layer and bring the liquid to a boil.

COVER

the pan tightly and simmer over medium-low heat for 45 minutes. Turn the pork shanks and ribbs and add the sausage. If there is not much liquid left, add more stock or water.

COOK

for another 45 minutes, or until the pork is tender and the liquid has reduced to a tasty sauce (you'll know it's ready when the sauce starts bubbling more thickly).

PLACE

the meat on a serving dish and dress with sauce.

SERVE

with polenta to mop up the sauce.

INGREDIENTS

1 to 2
skinless pork shanks, sliced
(same cut as for ossobuchi)

4
meaty ribs, cut in half

4
pure pork Italian sausages

4 tbsp
extra virgin olive oil

3
gloves of garlic,
finely chopped

25gr
sage and rosemary,
finely chopped

125ml
white wine

250ml
water (or 250ml stock,
recommended)

sea salt and black pepper,
to taste

preparation time
1h 45 minutes

serves 4

Platter
Salviati, 1880

SPEZZATINO DI MANZO IN UMIDO CON PATATE
(STEWED BEEF AND POTATOES)

This dish, a variation of traditional goulash, came to Venice via Austria. It must be said, however, that stewing is one of the most common cooking methods throughout the world—in India it's known as curry, in Morocco it's called a tagine, and so on. Whatever the name, meat's flavor comes from the working muscles, but the harder these muscles work, the tougher the meat. This is why stewing, with its slow, lengthy cooking process and absolute simplicity, is just what it takes to make the meat tender and juicy. In the past, people would choose a piece of meat, pop out to the vegetable garden, pick whatever was in season, and add it to the stewing pot. A little water and wine provided the final touch. Of course, the traditional porous cast iron pots cooking away for hours over a wood stove gave stews a flavor no modern kitchen range could ever achieve. If you adapt the recipe below for chicken thighs and drumsticks, remember that total cooking time should be one hour at the most, and this means you should add the potatoes after 30 minutes of cooking.

HEAT
the oil in a pot until very hot and sear the meat on all sides until it forms a nice golden brown crust. Season with salt and pepper.

ADD
the onions, garlic, and carrots and cook over low heat with lid on for 20 minutes, or until soft.

ADD
the porcini mushrooms along with the water they were soaked in (make sure you filter the water!), the tomatoes, and the red wine.

COOK
for a minimum of 1½ hours, or until the meat is almost done (use a roasting fork to check the softness of the meat).

ADD
the potatoes (and the peas if you are using them), and cook for an extra 30 minutes.

PLACE
in a serving dish, and accompany with a salad (you already have proteins, vegetables, and starch in the dish).

INGREDIENTS

1kg
beef, appropriate
for stewing (in other words,
not too lean)

20ml
sunflower oil

500gr
onions, sliced

500gr
carrots, cut into 4cm wedges

1 or 2
cloves of garlic, peeled

300gr
peas only in season (optional)

50gr
dried porcini mushrooms,
soaked in 200ml water
(optional)

300ml
red wine

800gr
peeled tomatoes
(either fresh or canned)

500gr
potatoes, cut into
3cm cubes

sea salt and black pepper,
to taste

preparation time
2h

serves 4

Plate
Fratelli Toso, 1970s

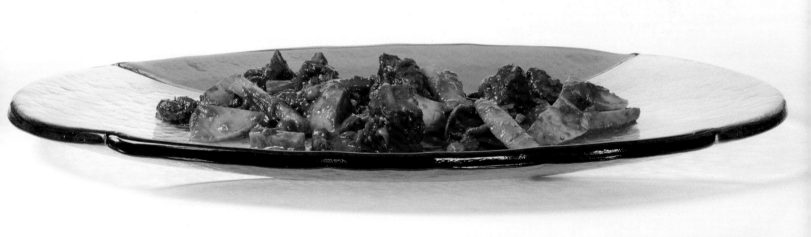

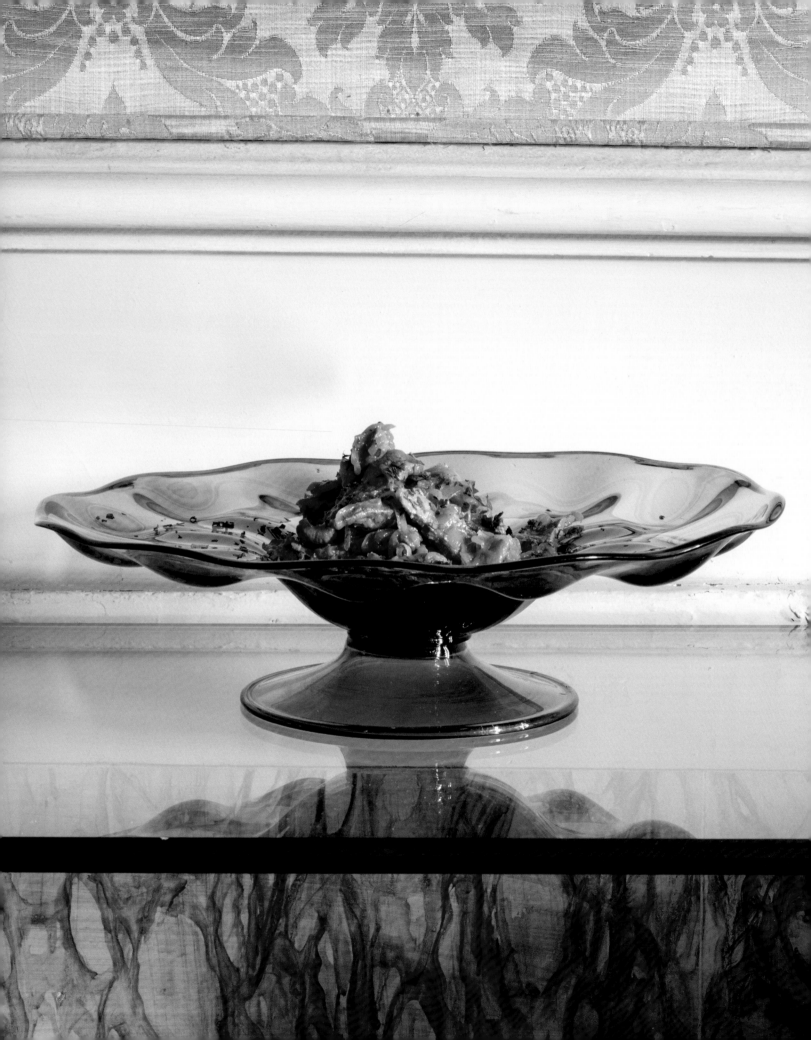

FEGATO ALLA VENEZIANA
(VENETIAN STYLE LIVER)

This dish was originally made with extremely flavorful pork liver, but as some people find the taste overwhelming (and also because it has become rather difficult to find) we now tend to use veal liver instead. Once again, the onions are used brilliantly to balance out the natural bitterness of the liver, thus creating a marvelously harmonious dish. Served with grilled polenta, it makes for a perfect, fully rounded meal.

PLACE

the oil in a frying pan and heat. Add the onions and cover. Soften the onions over low heat for 20–25 minutes, or until soft but not brown.

ADD

the white wine, cover once again, and continue to cook over low heat for another 60–90 minutes (the longer the better). When done, the onions should be very soft and all the liquid should be absorbed.

SLICE

the liver into 1–2cm pieces and add to the onions, then cook until the liver begins to brown. Be careful not to overcook the liver or it will become floury (depending on the size of your pieces, it should take no longer than 2–3 minutes). Season with salt and pepper, to taste.

PLACE

on a serving dish and garnish with freshly chopped parsley.

SERVE

with grilled white or yellow polenta.

INGREDIENTS

600gr
veal liver

3
medium onions,
finely sliced

4 tbsp
extra virgin olive oil

250ml
white wine (optional)

25gr
freshly chopped parsley

sea salt and black pepper,
to taste

preparation time
1h 45 minutes

serves 4

Stand
Seguso Vetri d'Arte, 1930s

SIDE DISHES

INSALATA DI CASTRAURE
(CASTRAURE SALAD)

When the *castraure* season (spring) starts, Venice goes crazy and wherever you go you'll find dishes with this amazing vegetable.
This small, delicate artichoke is the first that the plant produces, and it is removed from the plant in April so that it will develop another 18–20 artichokes. The name *castraura* comes from the word *castrare*, meaning to cut.
When you eat them raw you can truly appreciate their distinctive flavor, so this simple salad is really all you need to discover this incredible vegetable.
Castraure only come from the Venetian lagoon area, but you can substitute with any baby artichoke.

CLEAN
the baby artichokes by peeling off the hard outer leaves until you get to the softer inner leaves.

PEEL
the stem with a knife, leaving only the core.

SLICE
the artichokes very thinly and toss immediately in lemon juice to prevent them from turning brown.

DRESS
with extra virgin olive oil and parsley.

SEASON
with salt and pepper.

PLACE
on a serving dish and sprinkle with Parmesan cheese shavings (use a vegetable peeler for perfect shavings).

INGREDIENTS

8
baby purple artichokes

juice of 1 lemon

a little Parmesan, or any other mature cheese such as Pecorino

parsley, freshly chopped

extra virgin olive oil, for dressing

sea salt and black pepper, to taste

preparation time
15 minutes

serves 4

Bowl
Barovier & Toso, 1950s

PEPERONATA

This traditional Italian dish is great as an accompaniment to meat (pork, beef, or chicken) as well as on its own. Do not use green peppers as they are simply an unripe pepper; red and yellow peppers are recommended.
This dish can also be used as a pasta sauce. Cook the pasta (fusilli are best) as per packet instructions, toss with the peperonata, and then simply add a drizzle of extra virgin olive oil and a dusting of grated Parmesan for the perfect vegetarian meal.

CUT
peppers in half and deseed, then cut into 1cm strips.

ADD
oil to a pan and heat. When hot, add the onions and peppers, sprinkle with salt, then stir and cover with a lid. Bring heat down to low.

COOK
covered for 30 minutes over low heat, stirring very occasionally, to allow peppers and onion to release their water.

REMOVE
the lid and continue cooking over a slightly higher heat, stirring regularly until the onions and peppers have caramelized. They should start to stick to the pan slightly.

SEASON
with freshly chopped parsley, and salt and pepper to taste. Serve hot.

INGREDIENTS

**2
yellow bell peppers**

**2
red bell peppers**

**2
white onions,
very thinly sliced**

**4 tbsp
extra virgin olive oil**

**1 tbsp
freshly chopped parsley**

**sea salt and black pepper,
to taste**

preparation time
40 minutes

serves 4

Il tocco di Archimede
Massimo Nordio, 1998

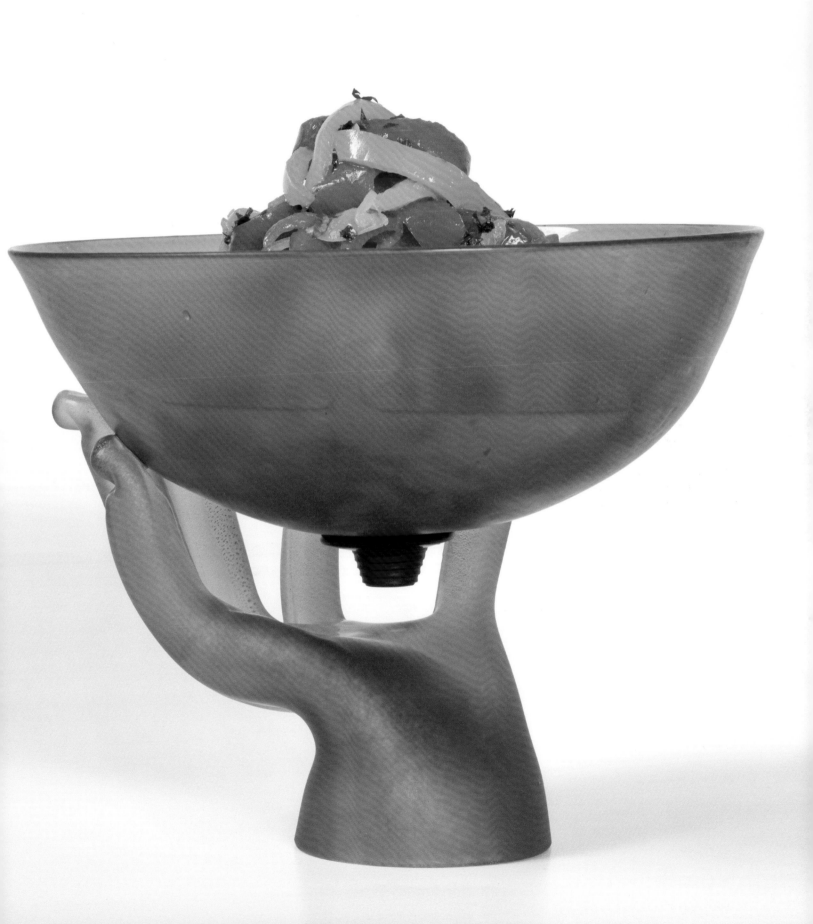

FONDI DI CARCIOFO
(ARTICHOKE HEARTS)

As I'm sure you're well aware, when it comes to large globe artichokes we are all more than willing to rip off, dip, and chew our way through as many of the outer leaves as necessary to get to the wonderful artichoke heart—the real reason for all that hard work. Venetians, however, decided that life is too short to go through all that hard slog, so globe artichokes are sold with all their leaves and hard bits already removed. You can just buy the hearts and enjoy them without any of the effort. Beware, though, that artichokes are very difficult to match with wines—their natural chemical makeup tends to make wines taste acid and water sweet.

POUR

the oil into a pan and heat.

WHEN

the oil is nice and hot, add the artichoke hearts, lying them flat and closely touching. Add the stock, parsley, garlic, and salt and pepper.

COOK

over low heat with lid on until all the liquid has evaporated.

SPRINKLE

with a little freshly chopped parsley. Serve warm.

INGREDIENTS

8
artichoke hearts

50ml
extra virgin olive oil

2 tbsp
freshly chopped parsley

2
cloves of garlic, sliced

200ml
chicken stock, or water

sea salt and black pepper,
to taste

preparation time
30 minutes

serves 4

ZUCCA AL FORNO
(BAKED PUMPKIN)

When winter arrives, the bright color of pumpkins always adds a happy note to the market stalls, and the pumpkin's creamy, sweet consistency makes it a perfect dish even just by itself.
There are many different varieties of pumpkins and some of them are better and sweeter then others, but all are usually very rich in water, so roasting them dries the water and concentrates the sugar and flavor.

PREHEAT

oven to 180°C. Place the pumpkin on an oven tray (form a single layer).

SPRINKLE

with the extra virgin olive oil, salt and pepper, and roughly chopped herb of your choice.

PLACE

tray in oven and bake until tender (this should take about 30 minutes, but will depend on the variety of pumpkin and how much water it contains).

SERVE

warm with any meat or fish. You can also transform the baked pumpkin into a salad by adding raisins, pine nuts, and shavings of Parmesan cheese.

INGREDIENTS

1kg
pumpkin, peeled and cut
into 4cm slices

rosemary, or thyme, or sage,
freshly chopped

40ml
extra virgin olive oil

sea salt and black pepper,
to taste

preparation time
40 minutes

serves 4

Oval plate and round plate
Massimo Micheluzzi, 2013

RADICCHIO ROSSO BRASATO AL MIELE
(BRAISED RED RADICCHIO WITH HONEY)

The radicchio from Treviso (which is only available during the winter months) is a very labor intensive product which is harvested and then placed in wooden cases in dark rooms until most of the outer leaves have rotted and the inner leaves are tender and a lovely red color. Once it reaches full maturation, the outer leaves are removed and the stem cleaned, making it finally ready to be sold. The markedly bitter taste can be overwhelming for some, so the honey from the Venetian *barene* in this recipe will help balance out the flavor. For this recipe you can also use other kinds of red chicory. It should be noted, too, that the radicchio's bitterness is the perfect accompaniment to fatty meats (fat is sweet, after all) and helps balance the flavors and cleanse the palate. This dish can also be prepared in a frying pan on the hob without altering the procedure.

PREHEAT
oven to 200°C.

WASH
the quartered radicchio and lay out in oven proof dish.

IN A CUP
thoroughly mix the red wine, balsamic vinegar, extra virgin olive oil, and honey, then pour over the radicchio.

BAKE
in the oven for about 30 minutes, or until tender.

SEASON
with salt and pepper to taste.

INGREDIENTS

2
large heads of Treviso radicchio (or other red chicory), quartered lengthwise

4 tbsp
extra virgin olive oil

70ml
good red wine

30ml
balsamic vinegar

1 tbsp
honey

sea salt and black pepper, to taste

preparation time
40 minutes

serves 4

Honey Vessels
Judi Harvest, 2013

Foglie di Murano
Judi Harvest, 2013

VERZE SOFEGAE
(STEWED SAVOY CABBAGE)

Even though the name of the recipe would literally translate into the rather gruesome "suffocated savoy cabbage," this simple and very humble dish is a wonderful accompaniment to *Maiale in tecia* (see page 116), or equally humble yet tasty grilled sausages. You could even cook the pork sausages with the cabbage if you wanted—just make sure you add the sausages toward to end of the preparation, as otherwise they'd be completely disintegrated by the time the cabbage is ready.

WASH
the finely sliced cabbage leaves thoroughly (little grains of sand or silt tend to collect between the tightly packed leaves).

IN A POT
heat the extra virgin olive oil, then add the onions, bay leaf, and cabbage. Stir thoroghly.

SEASON
with salt and pepper, then cover with lid. Cook for 20 minutes on low heat (do not add any other liquid).

ADD
the white wine vinegar and let evaporate.

COOK
on low heat with lid on for at least another hour, or until all the liquid has evaporated.

INGREDIENTS

600gr
savoy cabbage, finely sliced

1
onion, finely sliced

1
bay leaf

2 tbsp
extra virgin olive oil

20ml
white wine vinegar

sea salt and black pepper, to taste

preparation time
1h 45min

serves 4

CIPOLLINE IN AGRODOLCE
(SWEET AND SOUR BABY ONIONS)

This very specific variety of baby onion is difficult to find anywhere else in the world and is usually sold peeled and ready to pop in the pan. While traveling around the world, I've tried other varieties of onion, but none has really given the same result: I now know, however, that if I'm abroad I should use small shallots, which are the closest in terms of flavor. Unfortunately, you won't find these already peeled, and it can be quite a chore having to peel them one by one.

ADD

the butter to a pan and melt over medium heat.

WHEN

the butter begins to sizzle, add the onions and brown gently on all sides.

ADD

the water, then cover with a lid. Cook for approximately 20 minutes. In a glass, mix the vinegar with the sugar.

WHEN

the water has evaporated from the pan and the onions are softer, add the mixture of vinegar and sugar and cook uncovered until the vinegar has completely evaporated and the sauce is nice and thick (the onions have to caramelize in the sugar). Add salt and pepper to taste.

SERVE

very hot before the sugar solidifies. This is the perfect side dish to pork, beef, and venison.

INGREDIENTS

400gr
baby onions, peeled

50gr
butter

100ml
water

30ml
white wine vinegar

1 tbsp
caster sugar

sea salt and black pepper, to taste

preparation time
30 minutes

serves 4

Bowl and stand
Seguso Vetri d'Arte, 1940s

TEGOLINE IN TECIA
(GREEN BEANS WITH TOMATO SAUCE)

Fine, young green beans come into season in early July, and are a welcome arrival considering the *castraure* season is unfortunately over by then. There are many ways to cook and use green beans, but this recipe is just perfect as an accompaniment to meats.

REMOVE
ends from the green beans and wash thoroughly.

BRING
2lt of heavily salted water to the boil (the salt helps maintain the green color, and will be washed out after cooking).

ADD
the beans to the boiling water and cook for about 10 minutes, or until just slightly crunchy (they will complete their cooking in the sauce mixture later on).

DRAIN
the beans, rinse in very cold water, and set aside.

ADD
the extra virgin olive oil to a pan, heat, and add garlic. Fry for a couple of minutes.

ADD
the cherry tomatoes whole, sprinkle with salt, and cover with a lid.

WHEN
the tomatoes burst (this should take about 20 minutes) remove the pan from the hob. Mash the tomatoes with a potato masher or wooden spoon until smooth.

ADD
half the basil leaves.

RETURN
to heat and cook until all the water has evaporated and the sauce is creamy and smooth.

ADD
the beans and cook for 5 minutes, or until the beans are perfectly cooked and thoroughly warmed through.

SEASON
with salt and pepper, and add the remaining basil.

NOTE
that you can use 500gr of tomato passata instead of cherry tomatoes.

INGREDIENTS

600gr
young, fine green beans

2lt
water

400gr
cherry tomatoes (or 500gr tomato passata)

1
clove of garlic, peeled

50ml
extra virgin olive oil

1
handful of basil leaves

sea salt and black pepper, to taste

preparation time
40 minutes

serves 4

Plate from the *Tavolozza* series
Aristide Najean, 2013

MELANZANE AL FUNGHETTO
(EGGPLANT AL FUNGHETTO)

Literally translated as "eggplant mushroom style" (the eggplant in this dish does very much look like sautéed mushroom), this is a pretty common recipe throughout Italy, where, however, it almost always also includes tomatoes. Because we in Venice are lucky enough to have very tasty vegetables from the lagoon islands, we've completely eliminated the tomato in order to preserve the full flavor of our local eggplants.

Local eggplants are long, thin, and a light purple color, and we only ever use the skin and very little of the white flesh for this dish.

As you all probably know, eggplants are a veritable sponge when it comes to oil—the more you add, the more they will absorb. So you need to be careful not to add too much oil as, otherwise, they will become very heavy and unpleasant.

WASH

the eggplants, cut in half, and spoon out most of the white flesh so that all you're left with is the skin and about 1cm of flesh.

CUT

into 1cm slices, place in a colander with a good sprinkling of coarse sea salt, and set aside for 30 minutes to an hour. This will not only get them to release their bitter liquid, but will also stop them from absorbing too much oil during the cooking phase.

HEAT

the oil in a pan, then add the garlic. Cook for a minute over low heat.

USE

paper towels to dry the eggplants thoroughly, then add to the pan.

SEASON

with salt and pepper to taste, stir thoroughly, then cover with a lid.

COOK

over low heat until soft, then remove from heat and sprinkle generously with freshly chopped parsley. This is a perfect accompaniment to any meat dish.

INGREDIENTS

**1kg
eggplants**

**1
clove of garlic,
peeled and whole**

**30ml
extra virgin olive oil**

**3 tbsp
chopped parsley**

coarse sea salt

**sea salt and black pepper,
to taste**

preparation time
30 minutes

serves 4

Saturno bowl
Lino Tagliapietra
for La Murrina, 1969

POLENTA

Venetians once considered polenta to be their bread, and is still very common throughout the whole of northern Italy where corn is grown. It is usually made with yellow flour, except in Venice where white corn flour is preferred. Polenta perfectly accompanies any dish with a sauce (meat or fish), but it is also delicious grilled and eaten with cheese or salami.
It can be cooked and served either soft (as in *Gamberetti con polenta*, see page 50, *Fegato alla veneziana*, see page 121, or quite simply—my favorite—with a little farm butter and Parmesan cheese), or hard (grilled with cheese, cold meats, a stew, or any dish which could conceivably be accompanied by bread). Soft polenta should be creamy and served still hot with your favorite dish. If you want it hard, then it should be poured (in the form of a flattish round cake) onto a wooden board (a chopping board will do) as soon as it's cooked. Let it cool completely, then cut it into 3cm slices and grill on a BBQ or a grilling pan.
Currently, there are quite a few instant polenta flours available, and though they promise you perfect polenta in under three minutes it will be nothing like the real deal. A good *bramata* polenta flour should take at least 40 minutes to cook—and the longer you cook it, the better it is. Traditionally, polenta was cooked on a wood fire in a specially-made copper pot that can still be found in many Venetian kitchens. Of course you can prepare polenta on your stove in a normal, thick-bottomed pot, but it will never acquire that traditional smoky flavor that makes all the difference.

INGREDIENTS

1lt
water

300gr
polenta
(for hard polenta)

200gr–250gr
polenta
(for soft to medium-soft polenta)

1
heaped tbsp coarse salt

preparation time
1h

serves 4

BRING
 1lt of salted water to the boil, then slowly pour the polenta flour into the water while whisking constantly, making sure to avoid any lumps.

ONCE
 you reach a creamy consistency, bring the polenta back to the boil, lower the temperature, place a lid on the pot, and complete cooking at a very slow simmer for 40–50 minutes.

STIR
 vigorously every now and then (it is quite normal for the polenta to stick to the bottom and sides of the pan).

IF
 the polenta becomes too think, add a little boiling water.

Plates from the
Mori Venice Bar series
Aristide Najean, 2013

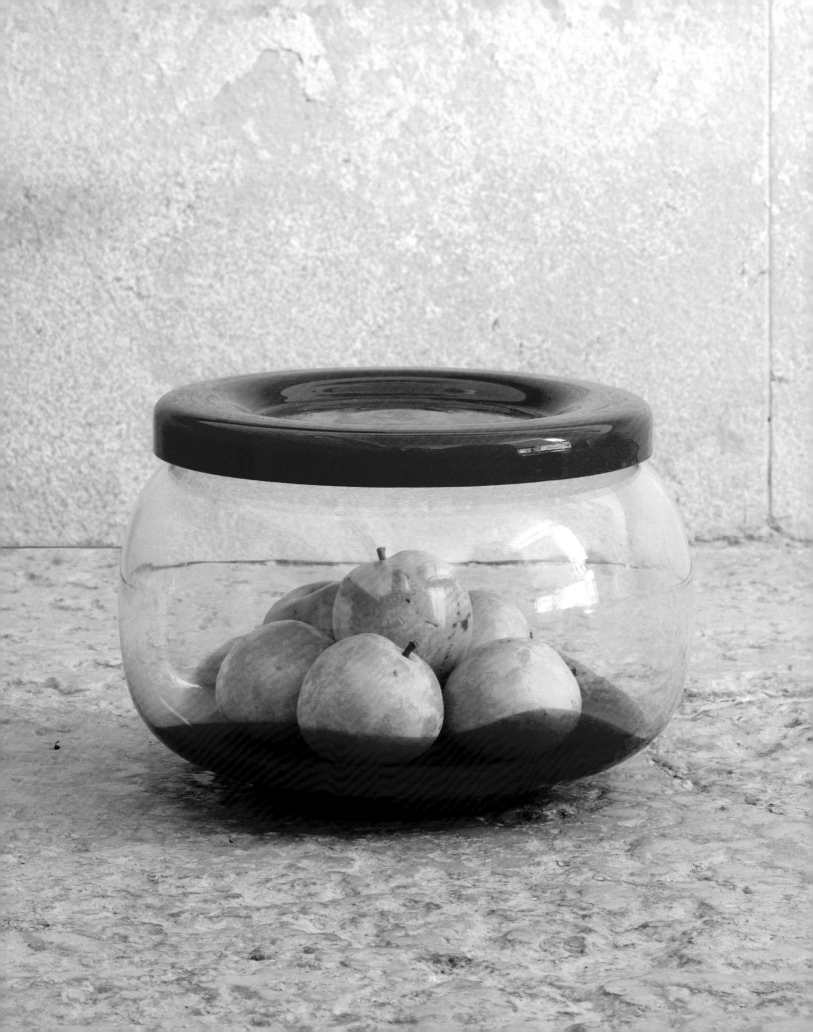

DESSERTS

FRITTELLE ALLA VENEZIANA
(VENETIAN FRITTELLE)

Venetian *frittelle*, or fried sweet dumplings, are the typical carnival sweet and, because baker's yeast is used to make the dough softer and lighter, they are completely different from the *frittelle* you'll find in the rest of Italy. Although the traditional *frittelle* are unfilled, in recent years Venetians have taken to using all sorts of sweet fillings. According to tradition, *frittelle* are always rolled in superfine, or caster, sugar while they're still hot so that the sugar adheres perfectly.

STEEP
raisins in the warm water until nice and plump, then drain and pat dry.

DISSOLVE
the yeast in a little warm water, and set aside for 5 minutes.

SIFT
the flour and salt into a bowl and blend thoroughly.

ADD
the sugar, the yeast mixture, and the eggs (one at a time) to the flour, and mix vigorously.

ADD
the rum and lemon zest. The mixture should now be very thick and gluey, making it very difficult to mix. If it's too thick to mix, add a little warm water.

COVER
the bowl with cling film, and put in a warm place (such as in the oven set at "defrost," or next to a radiator) to rise for at least 2 hours, or until the mixture has more than doubled in size.

ADD
the pine nuts and raisins to your mixture and continue to mix thoroughly. Cover and place in a warm area of your kitchen for about 30 minutes and let it rise again.

HEAT
seed oil in a frying pan making sure you use enough oil so that the *frittelle* will float and not touch the bottom of the pan. Use a spoon to scoop balls of the mixture into heated oil to fry.

WHEN
golden brown, use a slotted spoon to remove them from the oil, and drain thoroughly.

PLACE
on paper towel briefly to remove any excess oil, then quickly transfer to a bowl of caster sugar where you will coat the frittelle with sugar while they're still hot. Serve hot.

INGREDIENTS

500gr
manitoba flour

30gr
baker's yeast

1½ tumblers
warm water

120gr
sugar

2
eggs

100gr
raisins

50gr
pine nuts

10gr
salt

1 shot
of rum

zest
of 1 lemon

1lt
seed oil, for frying

superfine or caster sugar, for coating

preparation time
1h + resting time

serves 6

Plate
Luciano Vistosi, 1980s

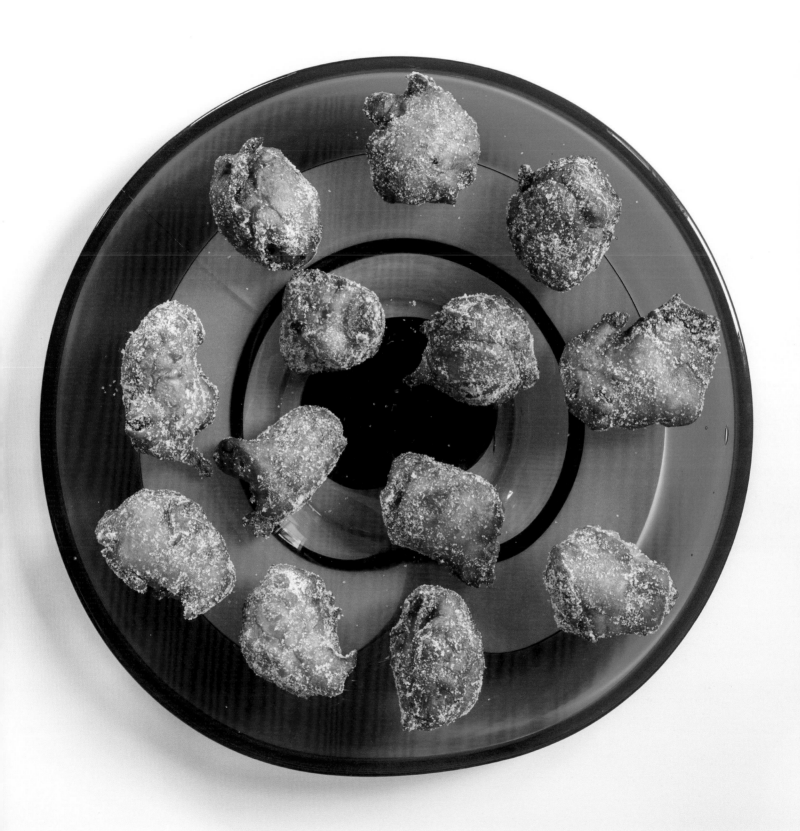

GALANI
(VENETIAN ANGEL WINGS)

Another typical carnival sweet, *galani* can be found throughout Italy—
Venetian *galani*, however, are thinner and crunchier than others.
In Venetian, the term *galan* means ribbon, and this is precisely what *galani*
are reminiscent of.

POUR
flour onto your work surface and mix in the sugar and pinch of salt.

BEAT
the eggs and white wine together lightly with a fork.

MAKE
a well in the flour and add the beaten egg and white wine mixture. Gradually mix
into the flour, then knead the dough vigorously for a few minutes and form into a ball.

USE
a rolling pin to flatten the dough, which should be no thicker than 0.5mm.

USE
an ordinary kitchen knife to cut the dough into rectangles (about 12cm × 7cm).
Make a diagonal cut (about 4cm) in the middle of each rectangle.

HEAT
seed oil in a frying pan making sure you use enough oil so that the *galani* will float
and not touch the bottom of the pan.

REMOVE
from oil with a slotted spoon once they are a golden brown and place on paper towels
to eliminate any excess oil.

DUST
with copious amount of confectioner's, or icing, sugar. Serve hot.

INGREDIENTS

500gr
plain flour

1
whole egg

2
egg yolks

4 tbsp
sugar

pinch of salt

½ tumbler
of sparkling
white wine

confectioner's,
or icing, sugar

seed oil, for frying

preparation time
45 minutes

serves 6

Bowl from the *Battuti* series
Tobia Scarpa and Ludovico Diaz
de Santillana for Venini, 1962

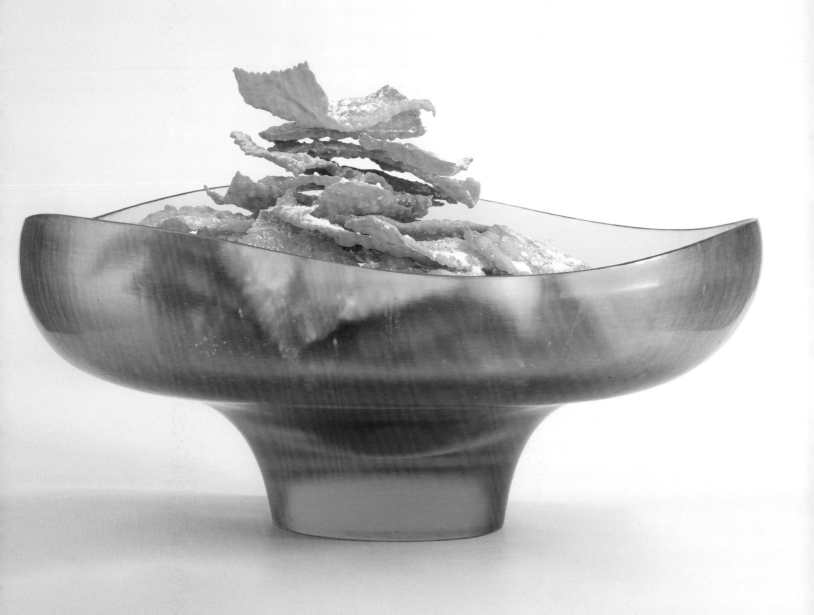

CREMA FRITTA
(FRIED PASTRY CREAM)

This is an amazingly mouthwatering dessert, made from the humblest of ingredients. It was typically made at home for the kids' after-school snack. Until a short time ago, fresh pasta shops also sold these diamond-shaped forms of solid cream, ready to be fried at home. Now, unfortunately, this tradition has died out, and the sweet is only ever home-made—naturally, in winter.

HEAT

the milk with the vanilla pod, without bringing it to the boil.

MIX

the flour, sugar, corn starch, and pinch of salt in a bowl. Then add the 2 whole eggs to the dry ingredients, followed by the 6 egg yolks one at a time, whisking vigorously in order to avoid any lumps.

SLOWLY POUR

the warm milk through a fine sieve or strainer into the flour, sugar, and egg mixture while continuing to whisk.

POUR

the mixture into a pan, place on the hob, and, while continually stirring, bring to the boil, making sure the mixture does not stick to the bottom of the pan or form any lumps.

BOIL

for about 2–3 minutes, then remove from the hob, and stir in the butter.

LINE

a baking tray or dish (about 26cm × 8cm, and about 5cm deep) with cling film, then pour all the mixture into the tray or dish. Cover with cling film (make sure the cling film actually touches the surface of the mixture), and refrigerate until it has solidified.

ONCE

it's nice and firm, place a sheet of parchment paper on your work surface and turn out the cream. Remove the cling film and cut into diamonds, each about 5cm long.

COAT

each diamond with breadcrumbs, pressing slightly to make sure the crumbs have firmly adhered to the surface.

HEAT

seed oil in a frying pan making sure you use enough oil so that the diamonds will float and not touch the bottom of the pan.

REMOVE

from oil with a slotted spoon once they are a golden brown and place on paper towels to eliminate any excess oil.

DUST

with superfine or caster sugar. Serve hot.

INGREDIENTS

500ml
milk

1
vanilla pod

85gr
flour

40gr
corn starch

100gr
sugar

pinch of salt

2
whole eggs

6
egg yolks

25gr
butter

150gr
breadcrumbs

1lt
seed oil, for frying

superfine or caster sugar,
for dusting

preparation time
40 minutes + resting time

serves 6

Kandinsky plate
Paolo Crepax, 1980s

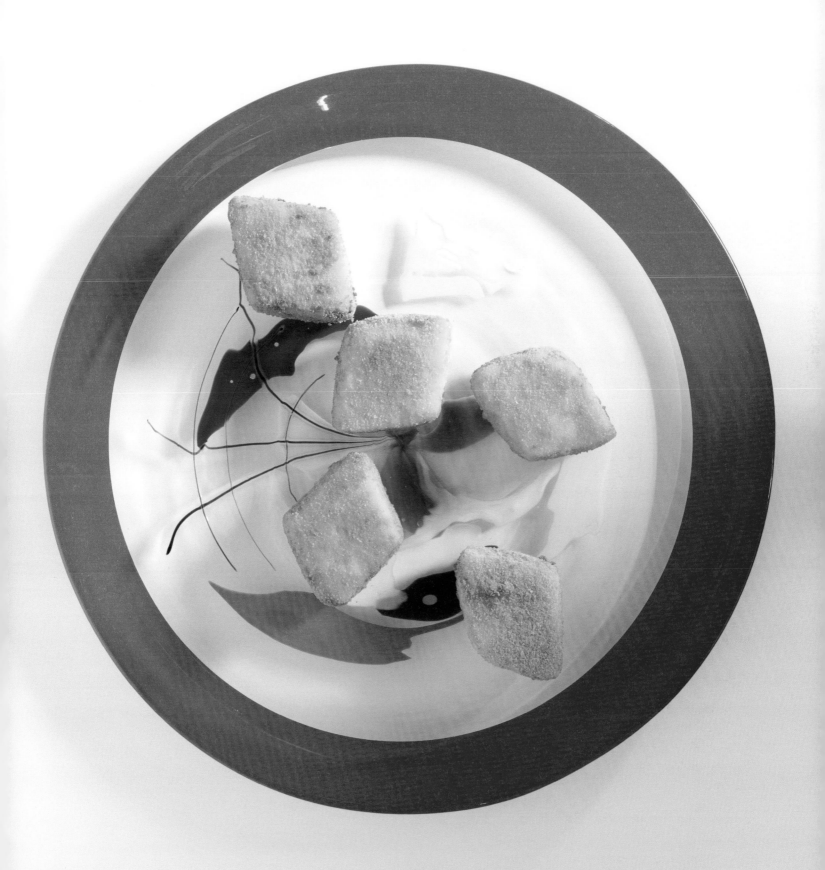

TIRAMISÙ

This is a modern dessert, for which there are infinite variations and which has quickly colonized the length and breadth of Italy. The extremely rich tiramisù is almost exclusively made from raw eggs, so you must be a hundred per cent sure this fundamental ingredient is as fresh as possible.

POUR
the coffee, still hot, into a bowl, and add your tbsp of Marsala, brandy, or rum. Stir until completely mixed, then set aside to cool.

SEPARATE
egg whites from yolks.

BEAT
the yolks with the sugar until the sugar has completely dissolved and the mixture takes on a very pale yellow color. Add the mascarpone cheese and mix thoroughly.

BEAT
the egg whites with a pinch of salt until stiff.

INCORPORATE
beaten egg whites into the egg and mascarpone mixture very delicately, stirring from the bottom up so as not to "deflate" the stiff whites.

PLACE
a little of the mascarpone and egg mixture onto the bottom of a rectangular cake tin.

QUICKLY
dip the Savoiardi or ladyfingers into the coffee, then place side by side at the bottom of the cake tin until it is completely covered.

COVER
this layer with a layer of the mascarpone and egg mixture.

CONTINUE
to alternate layers of biscuit and egg mixture until you've used up all the ingredients or completely filled the cake tin. Make sure your last layer is the mascarpone and egg mixture. You can also prepare your tiramisù in individual portions (you can use glasses or small bowls).

COVER
with cling film and place in the fridge for at least 3 hours.

DUST
with unsweetened cocoa powder just before serving.

INGREDIENTS

4
eggs

4 tbsp
sugar

300gr
mascarpone cheese

300ml
strong, Italian espresso coffee

1 tbsp
Marsala wine, brandy,
or rum

300gr
Savoiardi, or ladyfingers

cocoa powder

pinch of salt

preparation time
45 minutes + resting time

serves 6

Goti
Antica Murano, 2013

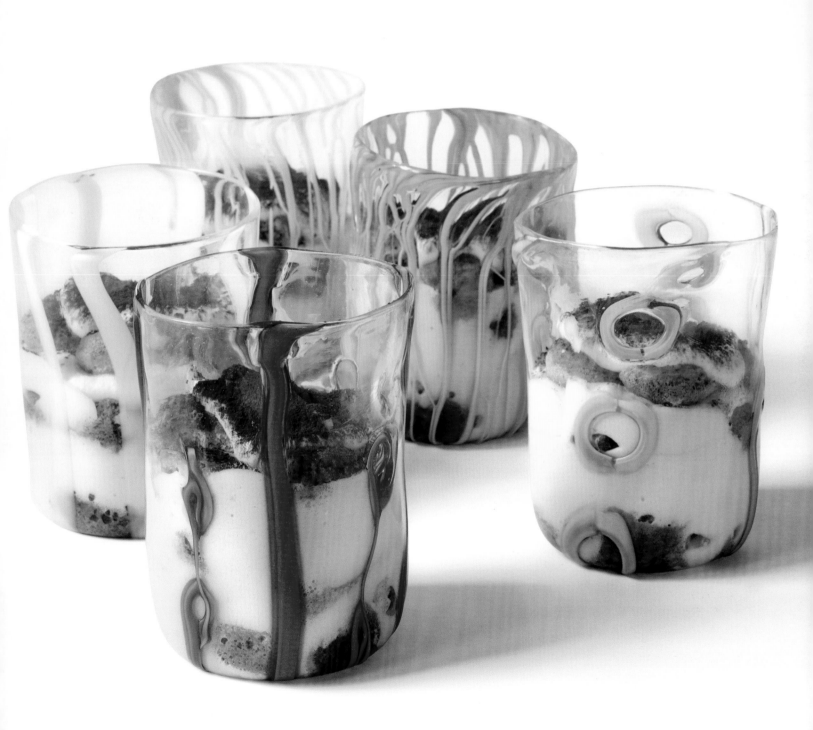

PANNA IN GHIACCIO
(ICED CREAM)

An extraordinarily simple yet rich and satisfying sweet, iced cream was once the Venetian summer sweet *par excellence*.

USE

an electric whisk to beat the cream and sugar until stiff. Pour mixture into an aluminum loaf baking tin (20 × 10 cm, and 5cm deep) with lid. Use a spatula to flatten the surface.

KNOCK

the baking tin on the table a couple of times to make sure you eliminate any air that might be trapped in the mixture.

PLACE

the baking tin in the freezer for at least 6 hours, or until the mixture has completely frozen.

ONCE

frozen, extract the block from its tin and cut into 1.5cm slices using a knife (warm the knife slightly by placing it under boiling water for a few seconds, and making sure you dry it thoroughly before cutting the slice).

SERVE

each slice of iced cream between two dry biscuits or wafers.

INGREDIENTS

**125ml
fresh cream**

**3 tbsp
superfine, or caster, sugar**

dry biscuits or wafers

preparation time
15 minutes + refrigerating time

serves 8

Quattro Stagioni. Estate plate
Laura Diaz de Santillana
for Venini, 1976

BUSSOLAI E ESSE
(BUSSOLAI AND ESSE)

The most sumptuous and famous of all Venetian *bussolai* recipes is from Burano. A cornucopia of eggs and butter, these biscuits have a consistency and aroma that is uniquely their own. They are indescribably good eaten dipped in a glass of good, sweet wine.

PREHEAT
oven to 170°C.

MELT
butter, then put aside to cool.

MIX
egg yolks and sugar until the sugar has completely dissolved.

ADD
a pinch of salt, lemon zest, and the seeds from the vanilla pod.

ADD
the flour and mix thoroughly, then knead until you have a ball of dough that is very similar to short crust.

COVER
with cling film and place in the fridge for half an hour.

DIVIDE
dough into two equal parts.

USE
the first part to make little doughnuts about 10cm in diameter.

USE
the other half to make little S-shaped biscuits.

BAKE
in preheated oven for 15–20 minutes, or until lightly browned.

INGREDIENTS

500gr
plain flour

6
egg yolks

250gr
sugar

200gr
butter

zest of 1 lemon

seeds from 1 vanilla pod

pinch of salt

preparation time
45 minutes + resting time

serves 6

Shell
Carlo Scarpa for Venini,
circa 1942

Small *Corroso* vase
Carlo Scarpa for Venini, 1936

Small *Corroso* bowl
Carlo Scarpa for Venini, 1936

Small *A puntini* vase
Carlo Scarpa for Venini,
circa 1937

following pages
Bocciolo plate and *Bee Glasses*
Ritsue Mishima, 2013

ZABAIONE
(ZABAGLIONE)

Served in a cup with a couple of *zaeti*, zabaglione is without any doubt a treat that packs more calories than you'd probably need in a month. It was once considered the perfect pick-me-up and given to students. Until very recently, it was traditionally given to the groom as the last course at the wedding banquet…

PREPARE

your bain-marie by putting 8–10cm of water into a saucepan and placing it on the hob to heat.

PUT

the egg yolks and sugar in a metal bowl and mix with an electric whisk until the sugar has completely dissolved and the mixture is light and fluffy. It should be a very pale yellow. Very gradually add the wine while continuing to mix.

PLACE

the metal bowl in the bain-marie, making sure the water is barely simmering and not at a full boil, that your bowl does not touch the bottom of the saucepan, and that no water or steam gets into your egg and sugar mixture.

CONTINUE

to beat with your electric whisk until the mixture is fluffy, smooth, and creamily dense. This should take about 10 minutes. Remove from the hob and serve hot or cold in a demitasse or glass fruit cup.

INGREDIENTS

water for bain-marie

4
egg yolks

80gr
sugar

200ml
Marsala wine,
or other fortified wine
(Passito, Moscato, etc.)

preparation time
30 minutes

serves 4

ZAETI
(POLENTA FLOUR COOKIES)

This is another classic Venetian biscuit or cookie, to be enjoyed with a glass of sweet wine or zabaglione. The name derives from the Venetian word for yellow, the color of the *polenta* flour.

PREHEAT

oven to 180°.

WHISK

butter and sugar together until completely blended and creamy.

ADD

the eggs and mix thoroughly. Add the pastry flour, the dry yeast, and pinch of salt, and continue mixing. Then add raisins and, to finish off, the polenta flour. Mix thoroughly.

USE

your hands to scoop out small amounts of the mixture to form small balls (about 4cm in diameter). Place these balls onto a baking tray covered with parchment paper, making sure there is a little space between each. For an oval shape scoop out the mixture with a tablespoon and, using a second spoon, form quenelles.

BAKE

in preheated oven for about 20 minutes. Serve cold, with a dusting of confectioner's, or icing, sugar.

INGREDIENTS

200gr yellow polenta flour

200gr pastry flour

2 eggs

100gr superfine, or caster, sugar

150gr raisins

150gr butter

pinch of salt

1 sachet of active dry yeast

confectioner's, or icing, sugar,
for dusting

preparation time
40 minutes

serves 6

BUSSOLÀ FORTE MURANESE
(STRONG MURANO BUSSOLÀ)

The entire lagoon area shares the traditional sweet and savory *bussolai*, and each island has handed its own recipe down from one generation to the next.

So, alongside the famous sweet Burano *bussolai* (see page 152) and the savory Chioggia *bussolai*, we also have a very unique sweet that is only ever made on the island of Murano, typically for the feast day dedicated to Saint Nicholas (the patron saint of glass blowers) and for Christmas. The recipe was a well-kept secret for ages, and only the handful of families who had access to it made the sweet for the entire island. As is often the case, there are many different versions—ours comes from an authentic Murano resident.

PREHEAT
oven to 165°C.

MIX
all the ingredients (except for the oil and almonds), keeping back some of the candied citron and chocolate for last-minute decorating.

DRIZZLE
a little oil on your work surface and your hands, then knead the mixture thoroughly. The mixture should now be very dense and gluey.

ONCE
you've mixed all the ingredients, shape the mixture into the form of a large doughnut and move it onto a baking tray covered with parchment paper.

BAKE
in preheated oven for about 20 minutes.

REMOVE
from the oven and decorate with the leftover candied citron and chocolate, and, optionally, sliced almonds.

COOL
completely, then set aside for at least one whole day before eating. The *bussolà forte* will last for two full weeks.

INGREDIENTS

500gr
plain flour

350ml (or 500gr)
molasses

100gr
candied citron,
chopped roughly

100gr
pine nuts

150gr
dark chocolate,
chopped roughly

1 shot
rum

pinch of white pepper

drizzle of oil, for work surface

30gr
almonds, sliced (optional)

preparation time
45 minutes + resting time

serves 6

Filigree plate
Barovier & Toso, 1960s

SAN MARTINO

The San Martino is only made in Venice and the immediately neighboring mainland, and is prepared only for the feast day dedicated to Saint Martin of Tours—November 11. The biscuit is shaped like a knight riding a horse, and reflects a popular legend according to which a Roman centurion doing his rounds came across a half-naked beggar. Filled with pity, he cut his cloak in half and gave one piece to the beggar. The following night, he dreamed that Jesus thanked him for his deed, and when he awoke he found that his cloak was whole again. The feast is particularly popular in Venice because one of Saint Martin's relics was held in the church of San Martino, and Venetian children still now go from house to house, asking for money or sweets as they sing and bang their pots and pants.

PREHEAT
oven to 180°C.

PLACE
flour on work surface, and form a well. Place sugar, pich of salt, and lemon zest into the well. Cut the butter into small cubes and place around the well hole. Break the eggs into the well.

MIX
the flour, butter, and eggs quickly, using only the tips of your fingers, until the mixture resembles large breadcrumbs.

CONTINUE
mixing and kneading quickly, then form the dough into a ball. Wrap in cling film. Place wrapped dough ball in the fridge for at least 2 hours.

USE
a rolling pin to flatten the dough, and cut into the shape of a horseman on a horse.

BAKE
in preheated oven for about 15 minutes. Remove from oven and cool.

MAKE
the icing by whisking the egg white with 1 tbsp of the confectioner's, or icing, sugar. Use an electric beater for better results.

ADD
a few drops of lemon juice and continue to whisk, adding a tbsp of confectioner's, or icing, sugar at a time, until you get just the right consistency. Color the icing with a few drops of food coloring.

SCOOP
the icing into an piping syringe or bag, and decorate your San Martino to your heart's content, adding chocolate chips, jelly candy, sprinkles, or whatever takes your fancy.

INGREDIENTS

150gr
butter

150gr
sugar

300gr
plain flour

300gr
confectioner's,
or icing, sugar

3
eggs yolks

1
egg white

zest and juice of 1 lemon

pinch of salt

chocolate chips, fruit jelly candy,
sprinkles, chocolate coins,
and so on, to decorate

food coloring, to taste

preparation time
1h 15 minutes + decoration time

makes 1 San Martino

Spirale plate
Ritsue Mishima, 2013

SGROPPINO
(SORBET COCKTAIL)

Lemon sorbet, from which the *sgroppino* derives, constituted a break between courses (usually between the meat and fish courses) during pantagruelian banquets, and served to pleasantly cleanse the palate, readying it for the next course.
The *sgroppino* is the modern, alcohol-tinged version of the sorbet, and is usually served at the end of a meal as a light digestive.

PLACE
the lemon ice-cream in a blender and mix until smoothly liquid.

ADD
Prosecco and vodka.

BLEND
until thoroughly mixed and velvety smooth.

SERVE
in a flute.

INGREDIENTS

**400gr
lemon ice-cream**

**3
glasses Prosecco wine**

**2
shots vodka**

preparation time
10 minutes

serves 8

Flutes from the *Rezzonico* series
Studio Venini, 2013

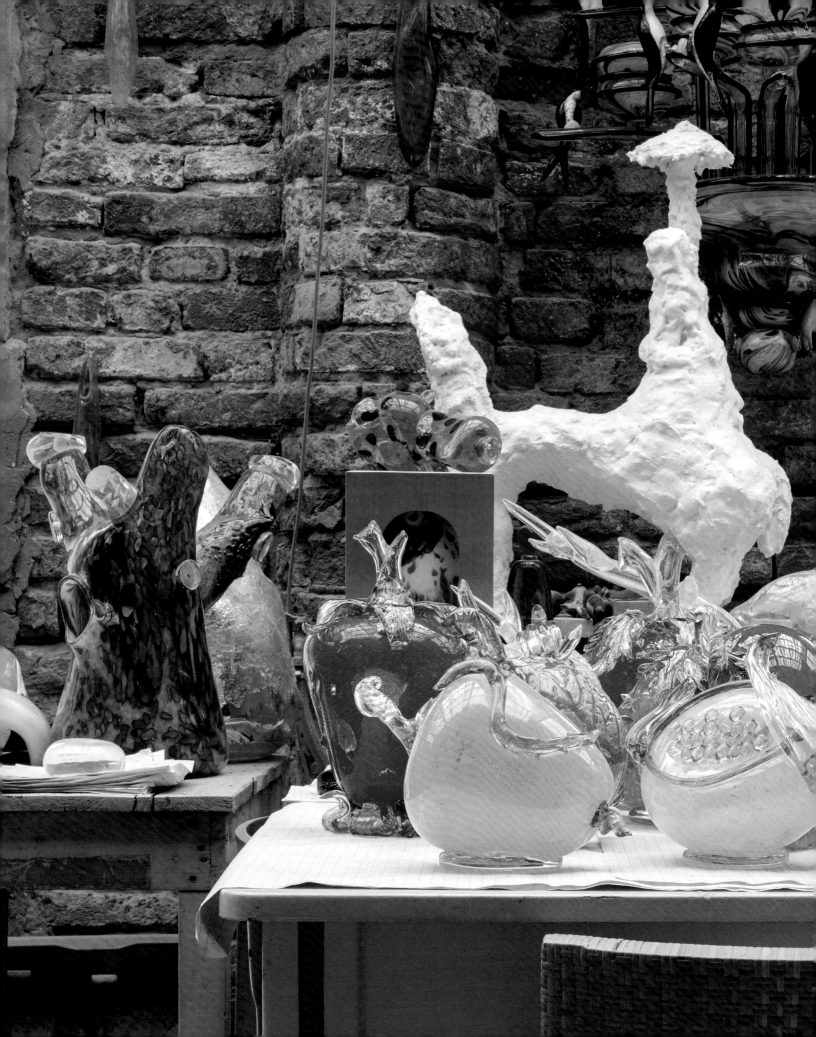

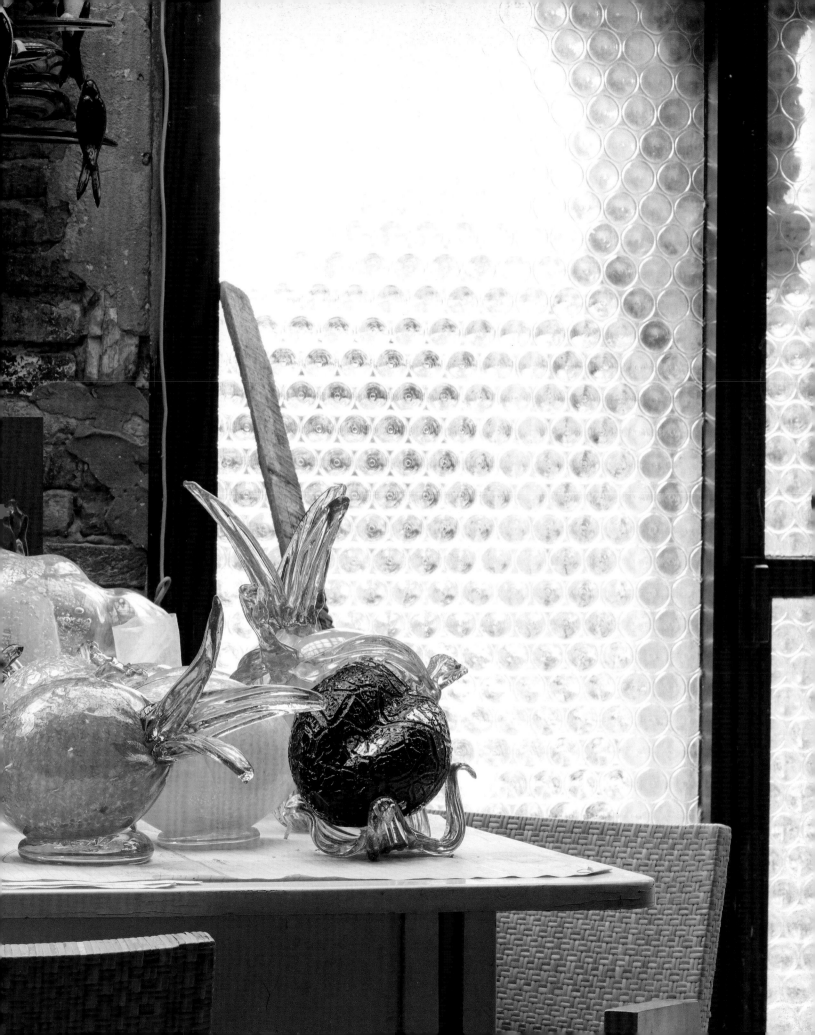

THE GLASS WORKS

Stand from the *Dysidea* series
celery green and ivory blown glass
h 22, ø 33 cm
Maria Grazia Rosin for CVM, 2008

La memoria e il suo peso
cut blown glass with silver inserts
h 30, l 18 cm
Massimo Nordio, 2013

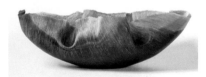

Tormalina
"Fillet de verre" hand molded by artist
19 × 59 × 26.5 cm
Toots Zynsky, 2013

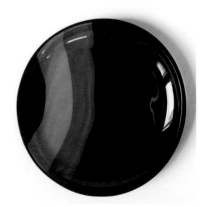

Plate from the *Tinta* series
black, orange, and blue blown glass
ø 23.5 cm
Lino Tagliapietra for Effetre International, 1984

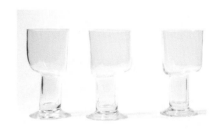

Glasses from the *Asimmetrico* series
blown lead crystal
h 19.5, ø 6.7 cm
Carlo Moretti, 1986

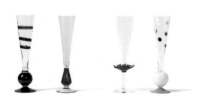

Glasses from the *Calici collezione* series
blown lead crystal
h 27, ø 8 cm
Carlo Moretti, 2007, 1994, 1993, 2009

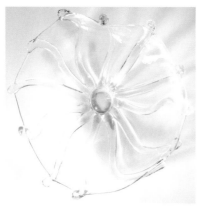

Petalo plate
blown lead crystal
h 18, ø 63 cm
Ritsue Mishima, 2013

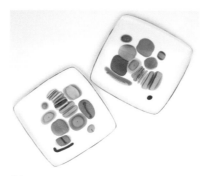

Plates
lead crystal with fused glass elements
21 x 22 cm; 22 x 22 cm
Marina and Susanna Sent, 2012

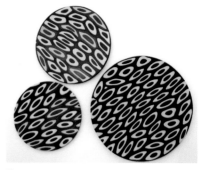

Plates
black and ivory murrine
ø 20, 22, 29 cm
Marina and Susanna Sent, 2010

Feathers
fused, molded zanfirico canes
41 cm
Massimo Nordio, 2004

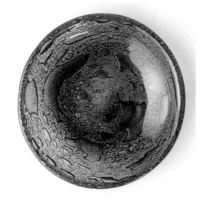

Efeso blu plate
blue blown glass with irregular internal bubbles
ø 22, h 5 cm
Ercole Barovier for Barovier & Toso, 1960s

Car 02/9
fused colored glass, wood, brass. Heat-fused glass cannes.
h 13 × 58 × 16 cm
Richard Marquis, 2002

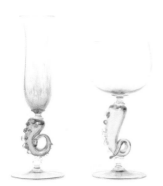

Flute and goblet from the Tentacolari series
ruby-colored blown glass and gold leaf
flute ø 6, h 25 cm; goblet ø 10, h 21 cm
Maria Grazia Rosin, 2005

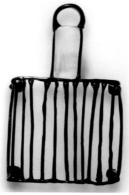

Grille
solid lead crystal with opaque black appliqués
37 x 25 cm
Fulvio Bianconi for Licio Zanetti Vetreria Artistica, 1970

Small goblet from the Battuti series
grape-colored blown, cut, battuto glass
h 6.5, ø 22 cm
Tobia Scarpa and Ludovico Diaz de Santillana for Venini, 1962

Oval plate
engraved white opaline glass and lead crystal, ground,
fused, and poured into mold
18.5 × 30, h 2 cm
Massimo Micheluzzi, 2013

Small stands and glasses from the *Tentacolari.*
***Gocce di polpo* series**
pink opaline blown glass
h max 15, ø 15 cm
Maria Grazia Rosin, 2005

Stand from the *Primavera* series
blown glass and gold leaf
ø 24, h 10 cm
Barovier & Toso, 1980s

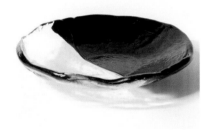

Plate
transparent black plate glass
ø 18 cm
Fratelli Toso, 1970s

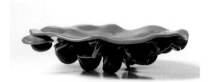

Plate from the *Dysidea. Riccio di mare* series
iridescent black and coral red blown glass
ø 40, h 10 cm
Maria Grazia Rosin for CVM, 2009

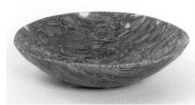

Round dish
engraved turquoise opaline glass and lead crystal,
ground, fused, and poured into mold
ø 22, h 4 cm
Massimo Micheluzzi, 2013

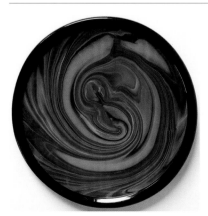

***Mercurio 2179* plate**
black, orange, and blue blown glass with multicolored
marbling
ø 35, h 2.5 cm
Ottavio Missoni for Arte Vetro Murano, 1988–1989

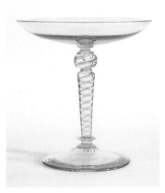

Stand
transparent blown glass with green and white zanfirico stem
ø 17, h 23 cm
Seguso Vetri d'Arte, 1930s

Bowl
light blue blown glass with shades of lilac
ø max 23, h 12 cm
Flavio Poli for Conterie e cristallerie, 1960s

Bowl
red and green incalmo blown glass
45 × 28, h 13 cm
Flavio Poli for Seguso Vetri d'Arte, 1955

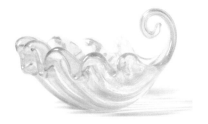

Shell-shaped bowl
iridescent lead crystal
h 15, ø 20 cm
Ercole Barovier for Barovier & Toso, 1942

Bowl
blown zanfirico cane glass
ø 17, h 6 cm
Lino Tagliapietra, 1989

Plate
orange blown glass
ø 29 cm
Murano production, 1980s

Plate with fishes
solid lead crystal with inserted multicolored fish
ø max 40 cm
Alfredo Barbini for Gino Cenedese, 1950

Filigree plate
blown glass with black edge
ø 32 cm
Barovier & Toso, 1980s

Totem
multicolored glass plates with multicolored fused,
molded glass cane inserts, with satin finish
80 × 16, h 6 cm
Massimo Nordio, 2004

Plate
cut, *battuto* blown glass
43 x 30 cm
Designed by Laura Diaz de Santillana,
made by Simone Cenedese, 1990s

Baccellato plate
red blown bubbled glass
ø 41 cm, h 4 cm
Murano production, 1920s

Canoa
blown, cut crystal colored glass
45 × 15, h 6 cm
Tobia Scarpa and Ludovico Diaz de Santillana
for Venini, 1960

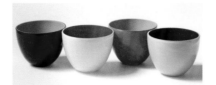

Small *Pirus* cups
blown lead crystal
ø 9.7 cm, h 9.7 cm
Carlo Moretti, 2001

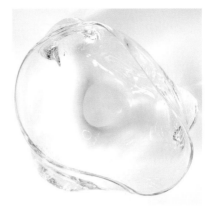

Bowl
blown lead crystal
l 48, h 18 cm
Ritsue Mishima, 2013

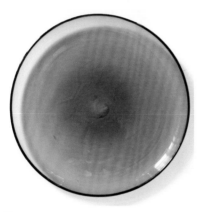

Plate
green blown glass
ø 34 cm
CVM, 1934

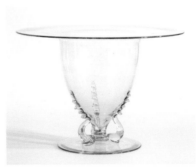

Bowl
pale blue blown glass
ø 22 cm, h 14 cm
Vittorio Zecchin for MVM Cappellin, 1920

Plate from the *Fasce nero e rosso* series
blown lead crystal
ø 39, h 6 cm
Carlo Moretti, 1989

Plate
blue, black, green and crystal-colored glass,
ground and fused
42 × 27, h 2 cm
Massimo Micheluzzi, 2013

***Loto* bowl**
lead crystal
26 × 20, h 13 cm
Salviati, 1980s

Flat plate
engraved opaque, ground, fused, molded glass
ø 25 cm, h 2 cm
Massimo Micheluzzi, 2013

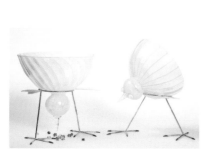

Tweens
blown zanfirico glass bowls, on enameled silver stand
19 × 23 cm
Massimo Nordio, 1998

Feather
fused, molded, silk-finished zanfirico
and murrine canes
65 × 16 cm
Massimo Nordio, 2004

Oval plate from the *Tinta* series
lattimo white, blue, and eggplant glass
31 × 29 cm
Lino Tagliapietra for Effetre International, 1988

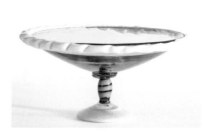

Small stand
peach-colored blown glass with lattimo and gold edge
ø 22, h 10 cm
Barovier & Toso, 1930s

Platter
pumpkin yellow blown glass
ø 27.5, h 3 cm
Salviati, 1880

Plate
transparent, green plate glass
50 × 38 cm
Fratelli Toso, 1970s

Stand
baccellato smoked glass
ø 37.5, h 20 cm
Seguso Vetri d'Arte, 1930s

Bowl
submerged, bubbled, dark green glass
ø 22, h 10 cm
Gino Cenedese e figlio, 1980s

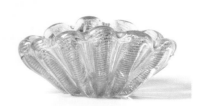

Bowl
cordonato d'oro glass
18 × 12, h 8 cm
Barovier & Toso, 1950s

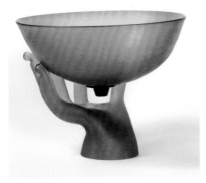

Il tocco di Archimede
blown glass goblet, with solid glass handle, silk-finished
ø max 22, h 18 cm
Massimo Nordio, 1998

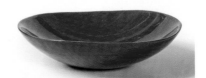

Round plate
engraved opaque deep red molded glass
ø 26.5, h 5 cm
Massimo Micheluzzi, 2013

Oval plate
engraved opaque deep red molded glass
34.5 × 19.5, h 2 cm
Massimo Micheluzzi, 2013

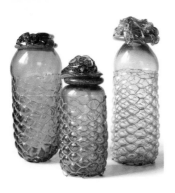

Honey Vessels
blown glass, gold leaf, and iron filament
ø 9, h 21 cm; ø 7.5, h 19; ø 8, h 23 cm
Judi Harvest, 2013

Foglie di Murano
transparent lead crystal
variable dimensions, max 29.5 × 21 cm
Judi Harvest, 2013

Bowl
transparent bubbled glass with coral and gold edges
ø 25, h 6.5 cm
Seguso Vetri d'Arte, 1940s

Stand
transparent bubbled glass with coral and gold edges
ø 26, h 8 cm
Seguso Vetri d'Arte, 1940s

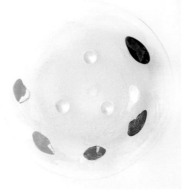

Plates from the *Tavolozza* series
blown hand-opened, heat-colored glass
ø 29 cm
Aristide Najean, 2013

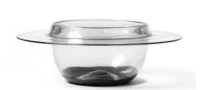

***Saturno* bowl**
aquamarine blown glass, with large murrine appliqué
ø 28, h 10 cm
Lino Tagliapietra for La Murrina, 1969

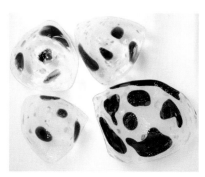

Plates from the *Mori Venice Bar* series
blown hand-opened glass with gold, silver, and aventurine
39 × 31; 27 × 23 cm
Aristide Najean, 2013

Vase from the *Susanni* series
red and crystal-colored blown glass
ø 27, h 19 cm
Matteo Thun and Antonio Rodriguez
for Venini, 2011

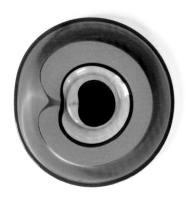

Plate
multicolored blown glass
ø 34 cm
Luciano Vistosi, 1980s

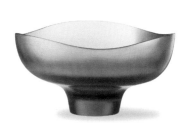

Bowl from the *Battuti* series
aquamarine blown, cut, and *battuto* glass
ø 37, h 15 cm
Tobia Scarpa and Ludovico Diaz de Santillana
for Venini, 1962

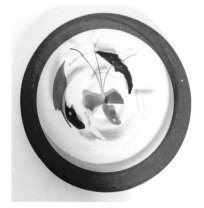

***Kandinsky* plate**
lead crystal with color inserts
ø 40 cm
Paolo Crepax, 1980s

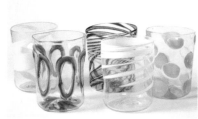

Goti
blown glass
ø 8.5, h 11 cm
Antica Murano, 2013

***Quattro Stagioni. Estate* plate**
incalmo blown glass with central murrine, cut
ø 35 cm
Laura Diaz de Santillana for Venini, 1976

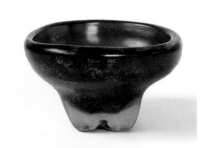

Small *Corroso* bowl
green, corroded blown glass
l 12, h 7.5 cm
Carlo Scarpa for Venini, 1936

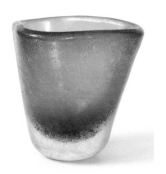

Small *Corroso* vase
pink, corroded blown glass
l 11, h 11 cm
Carlo Scarpa for Venini, 1936

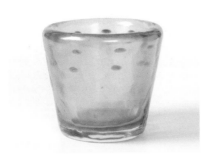

Small *A puntini* vase
crystal-colored blown glass with colored mottling
l 10, h 9 cm
Carlo Scarpa for Venini, circa 1937

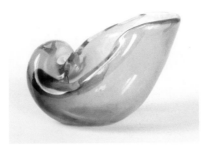

Shell
iridescent crystal-colored blown glass
l max 13, h 8.5 cm
Carlo Scarpa for Venini, circa 1942

***Bocciolo* plate and glasses**
Handmade single piece *sommerso* glass plate:
sommerso glass tumblers, opened while hot
plate ø 31, h 12 cm; glasses ø 6, h 8
Ritsue Mishima, 2013

Filigree plate
amethyst blown glass with pale blue support
ø 32.5 cm
Barovier & Toso, 1960s

***Spirale* plate**
Blown glass with glass spiral appliqué, applied while
hot, then opened
ø 43, h 2 cm
Ritsue Mishima, 2013

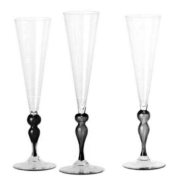

Flute from the *Rezzonico* series
blown glass with horizon-colored, sand,
and red heat-applied decorations
ø 8.6, h 26 cm
Studio Venini, 2013

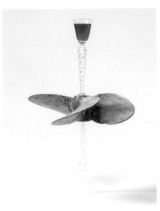

Untitled (Elica)
bronze boat propeller between two blown glass
hand-molded elements
h 42,5, ø 29 cm
Bruna Esposito, 2009

AN HOMAGE TO VENICE

Rocky Casale

There are two things about every chef that say a lot about their culinary acumen. One is how they shop for the best ingredients available. The other is the kitchen where these ingredients are eventually prepared. It helps to have a little culinary history under your belt, a curious nature, and a love for all things food. So when I first met Enrica Rocca on a cold January morning at Venice's Rialto fish and produce market, I knew almost instantly that I had met someone who not only ticked all of these boxes, but also a business woman with a passion so intense for her city that she could well be its ambassador.

In Enrica's case, her pantry is Rialto Market, and it is here that she has an intimate knowledge of the origins and quality of everything, from the spider crab at her fishmonger Marco's stall, to the porcini mushrooms that appear in the tonnage here in the autumn. Her kitchen and cooking school is a sort of snapshot of her entire life, with spices, cutlery, and cooking tools accumulated from her worldly travels, especially Japan, Africa, and, of course, Italy. Enrica's kitchen, in other words, can best be understood as her spiritual center, for when she is working there she is essentially at church.

The idea for *Venice on a Plate* came to Enrica one afternoon while she was drinking a spritz from a beautiful Murano glass goblet. She was visiting the glass store of her friend Fillipo Gambardella, who collects and sells antique and modern Venetian glass pieces. They talked about how cocktails seem to taste better when you drink them from thin, expertly crafted glasses. In Fillipo's shop she came across a black glass canoe made by Massimo Nordio, one of Venice's greatest living glass artists. There she began to envision the glass canoe filled with one of her recipes, perhaps a bright seafood salad, and how the colors of the fish would complement and be a dramatic contrast to this stunning piece of art. This inspiration of exquisite food and enchanting glassware, particularly Venetian glass, influenced her decision to create this unique and quintessentially Venetian cookbook.

While Enrica is without question a food connoisseur, Murano glass wasn't exactly her forte. It is something that she grew up around, but she never took the time to really discover this local industry in depth. Once she committed to this project, I witnessed and heard about the countless hours she spent learning about the craftsmanship and passion that goes into making Murano glass. And I came to understand that it is the same sort of craftsmanship and passion that Enrica feels and always applies to her cooking, and that she admires in great food producers the world over.

Enrica has talked to me about writing this cookbook for as long as I've known her, and it is something that she has wanted to do for over two decades. The book, though a mere glimpse of two fabulous Venetian arts, is informed and refined by her history, which includes studying at Switzerland's esteemed Ecole hôtelière de Lausanne, and running a restaurant and cooking schools in Cape Town, London, and Venice. Every time I am in her kitchen I am keenly aware that she has dedicated the bulk of her life, apart from her two daughters, to understanding what good ingredients are, and finding innovative and classic ways of preparing and presenting beautiful and delicious food. Measuring cups don't really exist in her kitchen, because for her the art of cooking is about practice, precision, and wisdom. And while *Venice on a Plate* is, in my opinion, an essential cooking compendium about Venetian cuisine, it is also a beautiful and intriguing study of how to marry art and food.

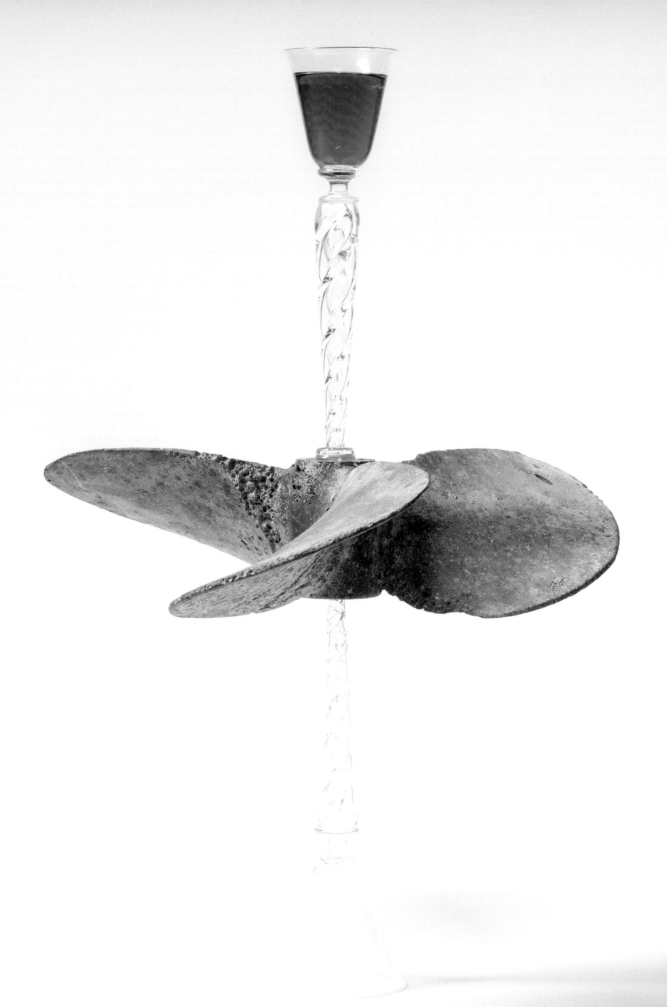

THANKS TO

One week before this book goes to print my mentor Marcella Hazan has sadly passed away.
I met her in 1990 in Cape Town when she was invited for a cooking demonstration. I still remember our first encounter at the Mount Nelson Hotel and her worries as she could not find all the ingredients she needed in a country still under embargo after apartheid.
I humbly invited her for lunch and shared with her my worries that the country needed her help and expertise to enhance food culture. I suggested she should open a branch of her cooking school in South Africa.
Her answer was simple: "Why don't you do it! This was the best Italian meal I've ever had outside Italy! You have a great kitchen, just spread our culture".
This is exactly what I did, and I never looked back. I can only thank this amazing woman who gave me the strength and confidence to follow my passion.
Marcella, I hope in your next life you will find the flavors, the textures, and the passion you transmitted to so many millions of people. Victor, my thoughts are with you as you were her pillar and she was yours.
With all my love and gratitude.

A special thank you to Filippo Gambardella, who helped me discover and understand the beauty of Venetian glass. The stunning pieces in your shop inspired this book, and your friendship and support helped me make my dream come true. Your crazy friend will forever be grateful, and I promise you that there will be no more spritzes in your shop!

My thanks also go to Professor Pierre Rosenberg, who very generously accepted to write an introduction to this book. The prospect of having such a prestigious individual introduce my work spurred me on to put extra effort into achieving levels that he might, if not be proud of, at least not be disappointed by.

To Rocky Casale, for such warm words in introducing me.

To all the glass artists who opened the door to their ateliers and workshops and private collections to help me make this book what it is, and namely
Judi Harvest
Massimo Micheluzzi
Ritsue Mishima
Aristide Najean
Massimo Nordio
Maria Grazia Rosin
Marina and Susanna Sent.

To Caterina Tognon, who lent me pieces by Richard Marquis, Toots Zinsky, and Bruna Esposito. These invaluable and breathtakingly beautiful objects have added great style and prestige to the book.

To Giulia Chimento from Venini, who offered me special access to both her vetreria in Murano and shop in San Marco, and also allowed Jean Pierre to turn everything in them upside down so that we could take our stunning photos.

To Alessandro and Alessandra Zoppi, who not only allowed me to use many pieces from their unbelievable collection of Venetian glass, but also opened the doors of their stunning palazzo so that we could take some amazing photos.

To Brian Tottle from the Carlo Moretti shop, who not only lent us many pieces from his collection but also welcomed the project with great enthusiasm.

To Sandro Pezzoli, who lent us invaluable pieces.

A warm thank you to Pierre Gabriel, an "enfant terrible" who accepted this challenge without batting an eyelid. Your complete and utter lack of discipline—the source of your genius and great aesthetic sense—delighted us all.
Merci de tòut cœur.

To Marco Bergamasco, my wonderfully madcap fishmonger at the Rialto markets, who always gives me the best of the best for my clients to experience.

To the Moro family, who run a wonderful vegetable stall at the Rialto markets, who sometimes even individually chose each fruit and vegetable for this book, and who always take the time to give me the best.

To Francesco and Matteo Pinto from All'Arco—you are my refuge, and the quality of what I eat in your wonderful, warm, welcoming bacaro each day has inspired some of these recipes.

To my assistant Francesca Bellotto, who organizes my life and takes care of everything when I am busy pursuing my dreams.

To my beautiful daughters Charlotte and Claire, who are always there for me when I need them and who helped me in writing this book.

To all my friends around the world, who always encourage me to give the best of myself.

This book would never have seen the light of day if not for a team of motivated individuals who indefatigably invested their energy and human resources from the very get go. A special thank you goes to Luca De Michelis and Rossella Martignoni, who had no qualms about accepting my project; to Martina Mian, whose passion for cuisine knows no bounds and who couldn't wait to have her dream of putting together a cookery book come true; and to Stefano Bonetti, whose design for this book oozes precision and passion.
My thanks also go to my translators and editors.

A thank you also to
Alvise Basaglia
Gianni De Checchi
Meghan Gambardella
Paola Gaudioso
Claudio Gianolla
Marta Martini
Ana Milijanovic
Cinzia Peresino
Luisa Rocca Lunardoni
Katarina Rothfjell
Renato Salmaso
and to
Gelateria Al Ponte, Murano
Nuova Pizzeria Marlin, Murano
Ortofrutta Bacci, Venice
Ortofrutta Santin, Venice
Osteria ai Frati, Murano
Osteria da Lele a la Busa, Murano
Pescheria Gianni Donaggio, Venice
Pescheria Luca D'Este, Venice
Ristorante Da Raffaele Venice
Snack Bar Toletta, Venice

The publishers would like to thank Venezi@Opportunità,
a special company of Venice's Camera di Commercio,
for allowing us to use the slogan they coined for their 2011
promotional event.

cover
Car 02/9, glass, wood, brass, Richard Marquis, 2002

captions
page 6: *Il re del bosco* chandelier, Aristide Nejean, 2013
pages 164-165: Centerpiece, Aristide Nejean, 2013

photographs and food styling
Jean-Pierre Gabriel

color re-touching of images
Benjamin Gaspart

copy editing
Lemuel Caution

For the photographs ©Jean-Pierre Gabriel

© 2013 by Marsilio Editori® s.p.a. in Venice
First edition October 2013
isbn 978-88-317-1504-1

www.marsilioeditori.it

reproduction and printing
Graphicom srl, Vicenza

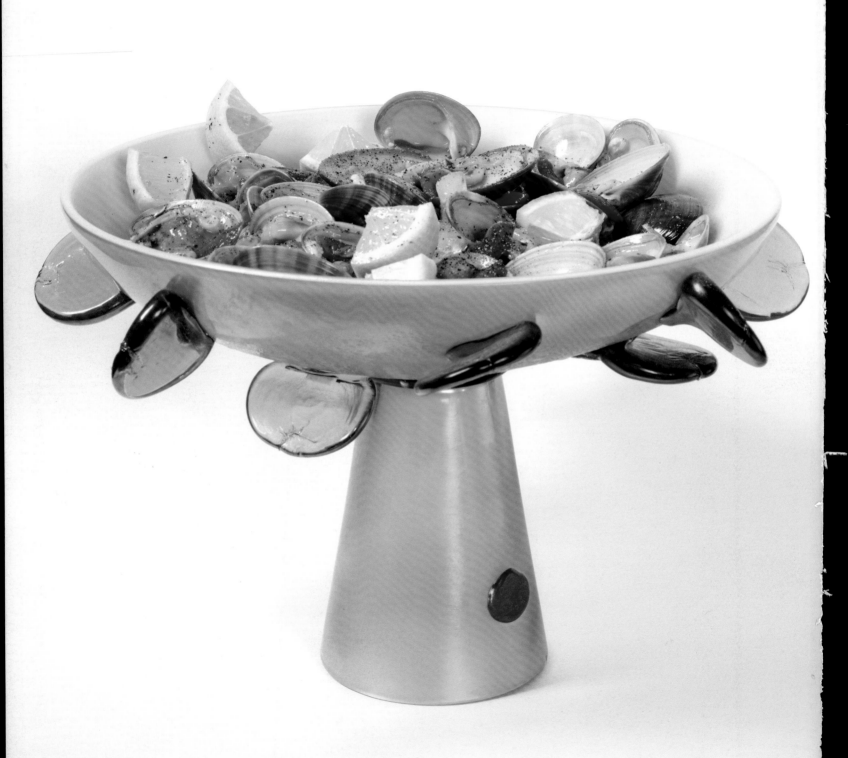